HOW TO DRAW Space gladiators

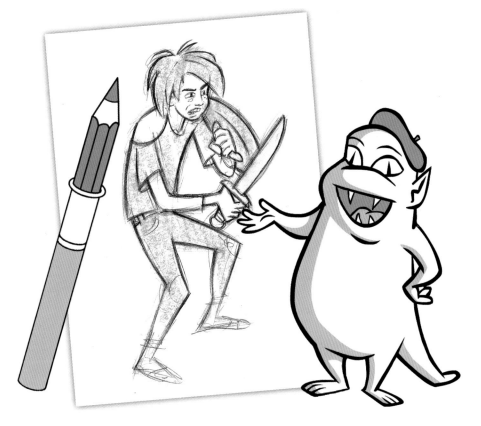

BY DANA MUISE

www.walterfoster.com

ABOUT THIS BOOK

Is there anything cooler than space monsters? No way. And who doesn't love drawing action-packed combat? Put the two together and you've got **How to Draw Space Gladiators**. This book will teach you how to draw alien space warriors as they fight to the death in the notorious intergalactic gladiatior arena aptly named **Space Monster Battle Planet**. Some will win, most will lose, but YOU will draw the action!

SOME ADVICE ABOUT DRAWING FOR BEGINNERS

All art forms take practice. It doesn't matter if it's drawing, writing, dancing, or playing music, the only way an artist can grow creatively is through practice. When I was a kid I copied everything—from my sister's Archie comics to the Sunday funnies. One time I copied an entire issue of *The Incredible Hulk* comic from cover to cover, including the ads! As a beginner, I found the best way to learn how to draw like the pros was to mimic what they did. It was a great exercise. In time I developed my own drawing style, but much of what I learned stayed with me to this day. Feel free to practice copying any monster in this book; heck, even trace it if you want. The important thing is that you are drawing. Over time some of the things you imitate will stay with you and develop into your own style. Most artists carry around a small sketch book and draw anything they can whenever they get a chance. What a great idea! Pick up a pocket-sized sketch pad and try drawing one monster every day. I promise you'll love it! Enough blabber, let's draw some monsters!

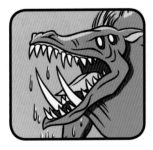

THORCLOPS
PAGE 14

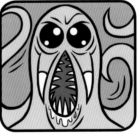

TROG
PAGE 68

SPACE DEVIL
PAGE 31

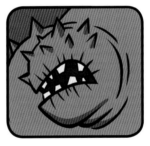

DIABOLICUS
PAGE 86

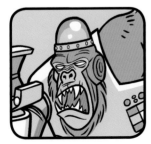

GORILLATRON
PAGE 49

PSYCHOZOID
PAGE 107

2

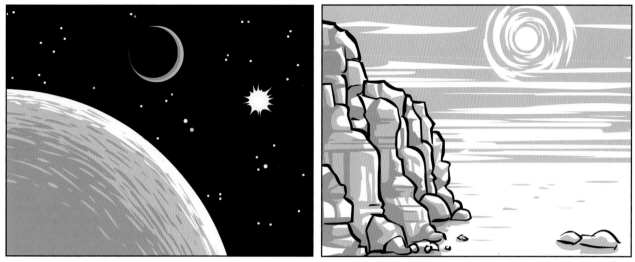

ON THE EDGE OF TIME, IN SOME UNCHARTED SECTOR OF THE UNIVERSE SITS A DRY AND DISMAL PLANET. ITS HOSTILE WEATHER AND SUN-SCORCHED LANDSCAPE PROVIDE THE PERFECT BACKDROP FOR THE MOST FANTASTIC GLADIATOR GAMES OF ALL TIME...

WELCOME TO *SPACE MONSTER BATTLE PLANET!*

SPACE MONSTER
BATTLE PLANET

HERE YOU WILL SEE THE MOST TERRIFYING GLADIATORS FIGHT TO THE DEATH UNTIL ONLY ONE IS LEFT STANDING TO CLAIM THE TITLE OF *MOST POWERFUL WARRIOR IN THE UNIVERSE!*

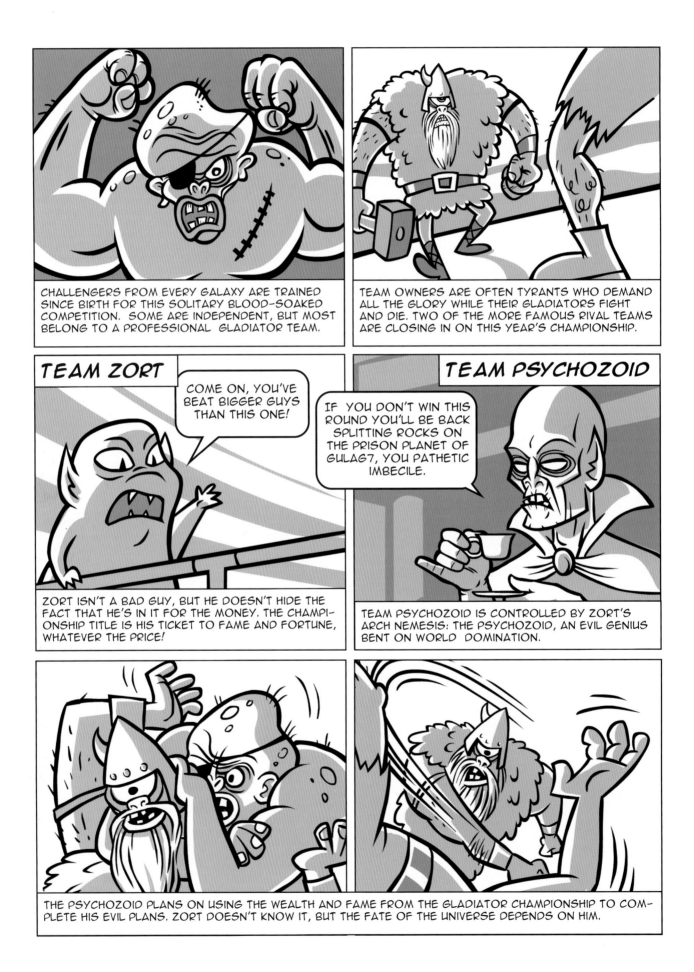

CHALLENGERS FROM EVERY GALAXY ARE TRAINED SINCE BIRTH FOR THIS SOLITARY BLOOD-SOAKED COMPETITION. SOME ARE INDEPENDENT, BUT MOST BELONG TO A PROFESSIONAL GLADIATOR TEAM.

TEAM OWNERS ARE OFTEN TYRANTS WHO DEMAND ALL THE GLORY WHILE THEIR GLADIATORS FIGHT AND DIE. TWO OF THE MORE FAMOUS RIVAL TEAMS ARE CLOSING IN ON THIS YEAR'S CHAMPIONSHIP.

TEAM ZORT

COME ON, YOU'VE BEAT BIGGER GUYS THAN THIS ONE!

ZORT ISN'T A BAD GUY, BUT HE DOESN'T HIDE THE FACT THAT HE'S IN IT FOR THE MONEY. THE CHAMPIONSHIP TITLE IS HIS TICKET TO FAME AND FORTUNE, WHATEVER THE PRICE!

TEAM PSYCHOZOID

IF YOU DON'T WIN THIS ROUND YOU'LL BE BACK SPLITTING ROCKS ON THE PRISON PLANET OF GULAG7, YOU PATHETIC IMBECILE.

TEAM PSYCHOZOID IS CONTROLLED BY ZORT'S ARCH NEMESIS: THE PSYCHOZOID, AN EVIL GENIUS BENT ON WORLD DOMINATION.

THE PSYCHOZOID PLANS ON USING THE WEALTH AND FAME FROM THE GLADIATOR CHAMPIONSHIP TO COMPLETE HIS EVIL PLANS. ZORT DOESN'T KNOW IT, BUT THE FATE OF THE UNIVERSE DEPENDS ON HIM.

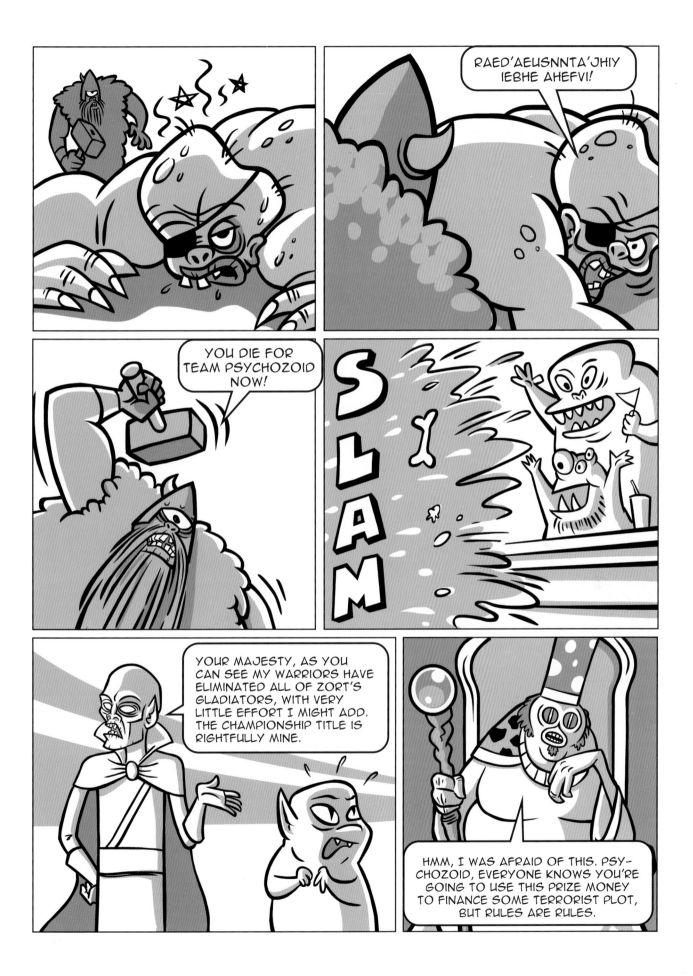

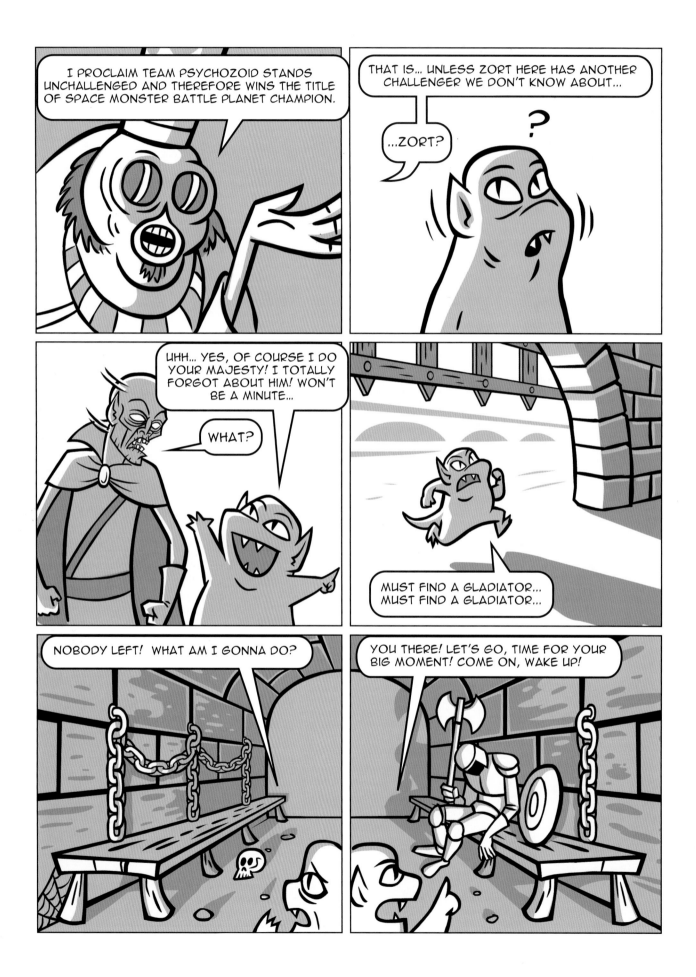

6

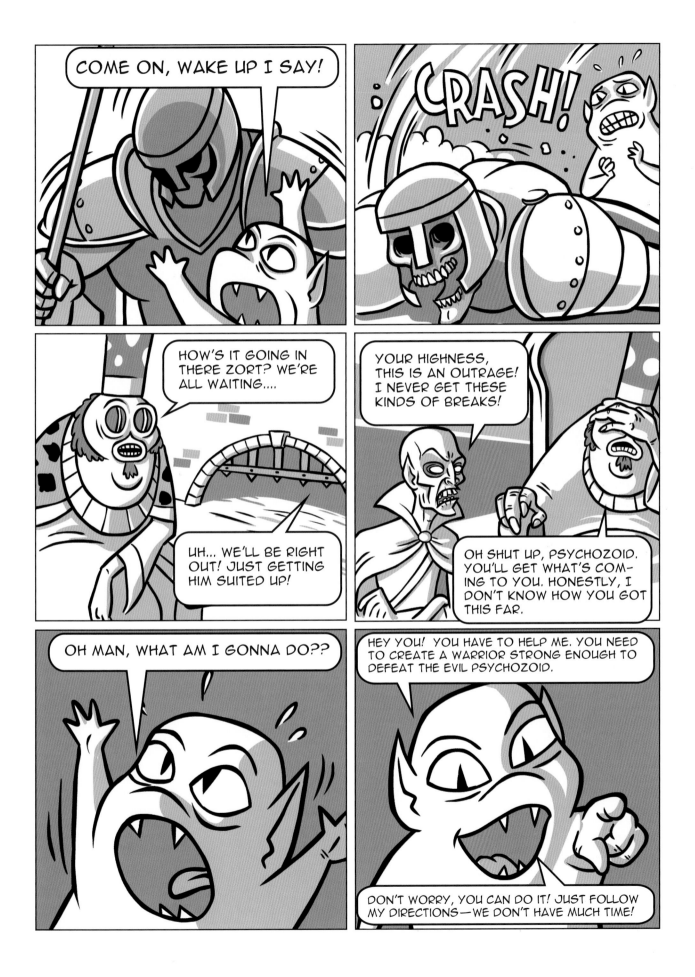

TIME TO GRAB YOUR PENCIL AND PAPER, AND START DRAWING! MOST BOOKS SAY YOU NEED TO STUDY ANATOMY TO DRAW PEOPLE. THE CHARACTERS WE WILL DRAW ARE MORE CARTOON-ISH, SO DON'T WORRY IF THINGS AREN'T PERFECT. AS LONG AS YOU HAVE FUN DRAWING, THAT'S WHAT REALLY MATTERS!

Deke Drifter

DEKE DRIFTER COMES FROM A SMALL TOWN IN CENTRAL IOWA, OR MAYBE HE'S FROM SOUTHERN CALIFORNIA... IT DOESN'T MATTER. HE'S YOUNG AND INEXPERIENCED, BUT HE WILL LEARN WITH EACH BATTLE. DEKE WILL BE UP AGAINST THE BIGGEST AND STRONGEST OPPONENTS IMAGINABLE, SO GIVING HIM A PUMPED-UP BODY WOULD BE POINTLESS. WE'RE GOING TO CREATE A LEAN, SVELTE WARRIOR THAT RELIES ON HIS WITS AND AGILITY.

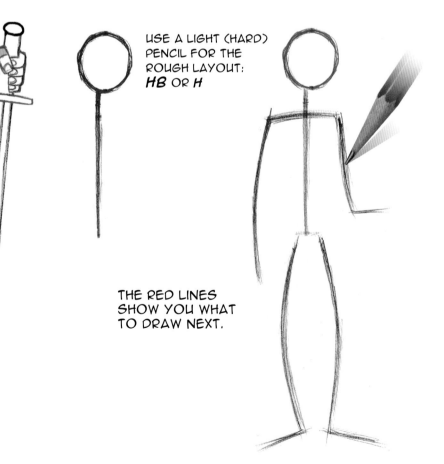

USE A LIGHT (HARD) PENCIL FOR THE ROUGH LAYOUT: *HB* OR *H*

THE RED LINES SHOW YOU WHAT TO DRAW NEXT.

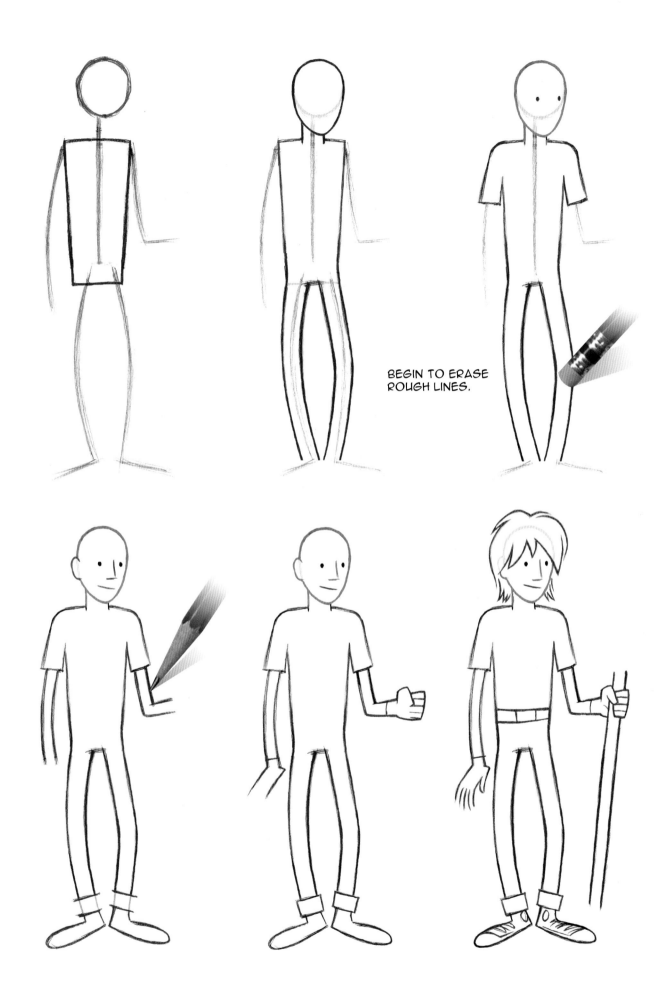

BEGIN TO ERASE
ROUGH LINES.

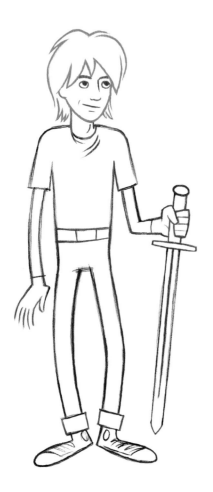
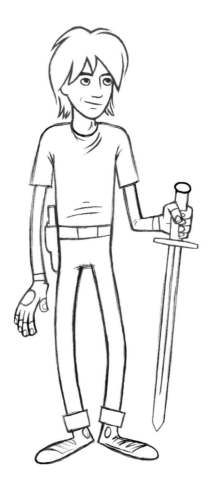
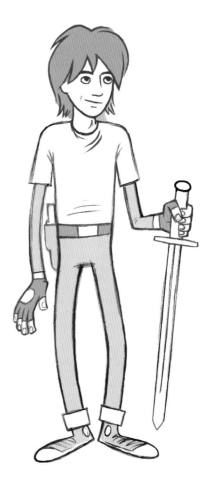

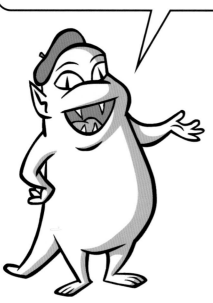

SEE, THAT WASN'T SO HARD! LET'S TRY ANOTHER ONE. THIS TIME GIVE DEKE AN ACTION POSE.

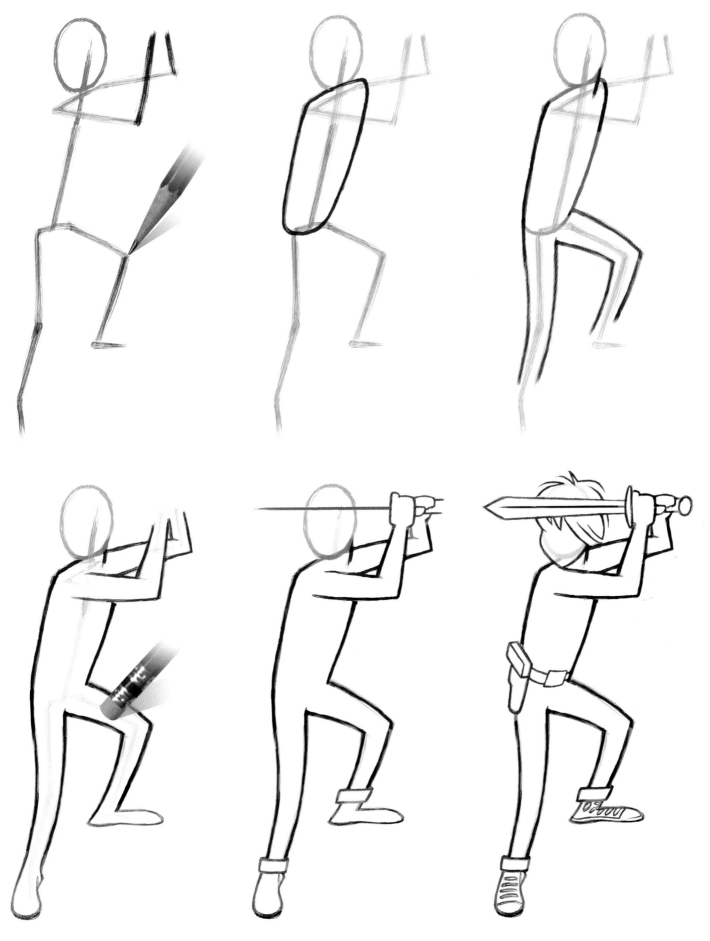

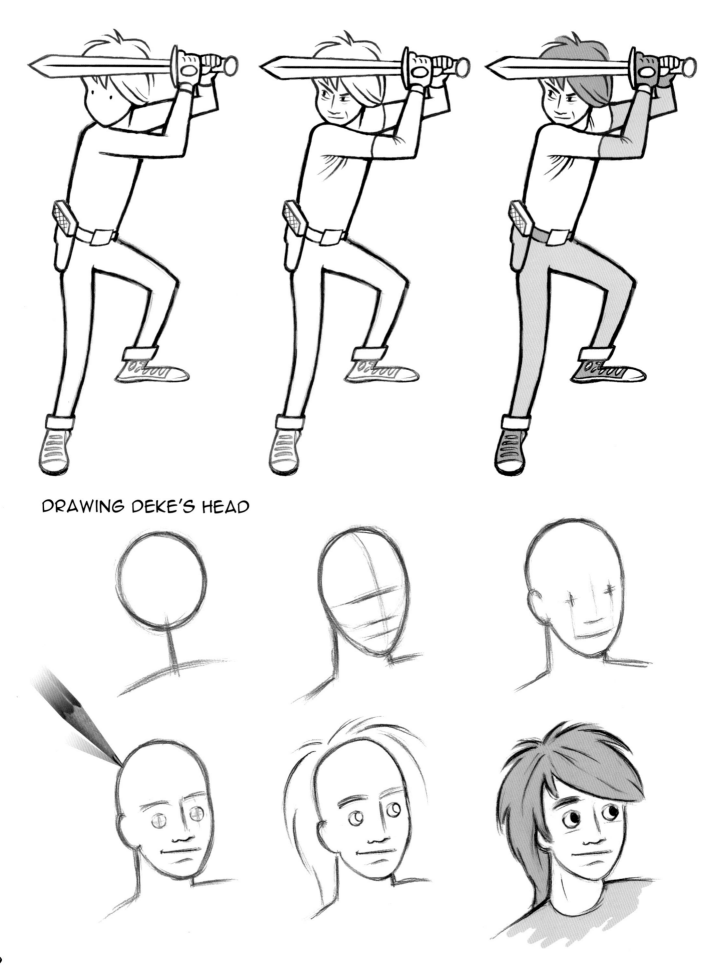

DRAWING DEKE'S HEAD

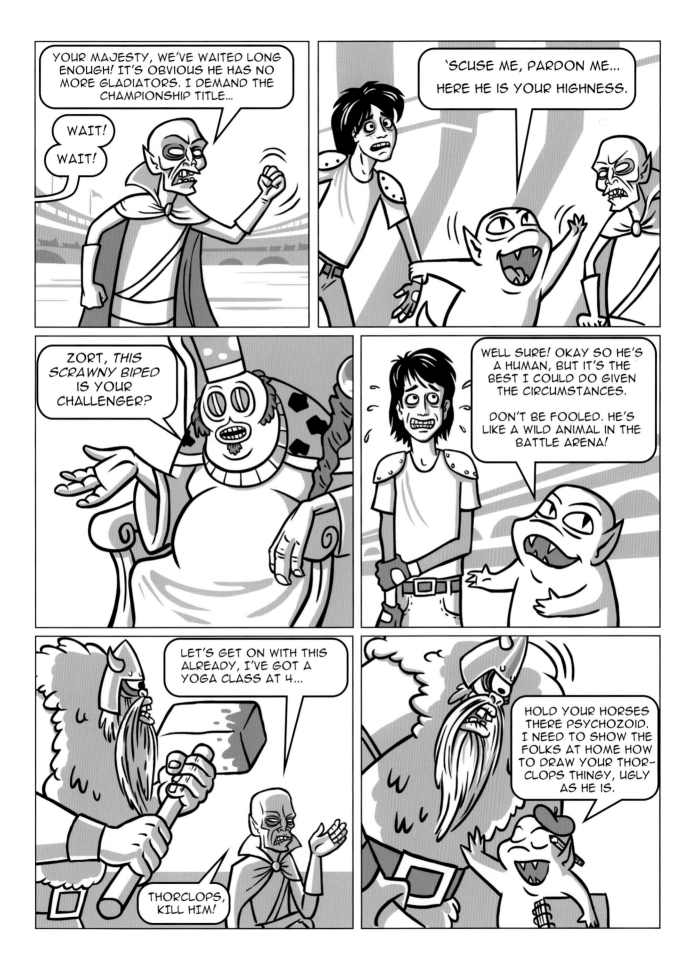

Thorclops

THIS CHALLENGER HAILS FROM THE ICY PLANET OF SVENTURIAN. THORCLOPS "THE DESTROYER" IS STRONG BUT EASILY OUT-MANEUVERED. HIS SINGLE EYE DOESN'T PROVIDE HIM WITH MUCH VISION, AND HE'S VULNERABLE IF BLINDED. STAY CLEAR OF HIS MIGHTY HAMMER: IT CAN ANNIHILATE AN OPPONENT WITH A SINGLE BLOW.

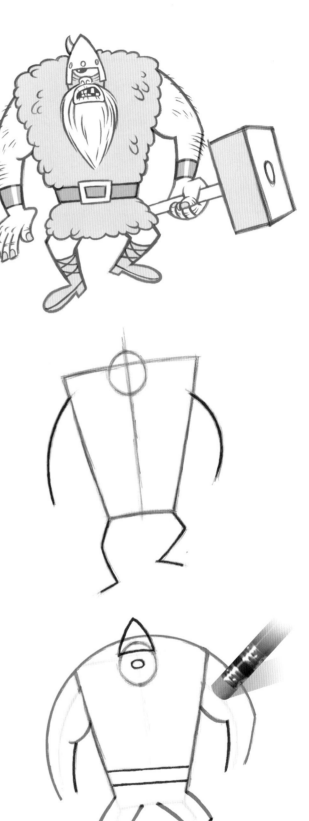

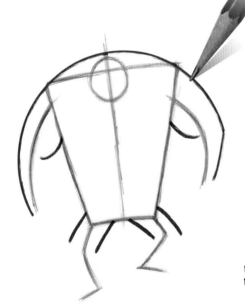

BEGIN TO ERASE ROUGH LINES.

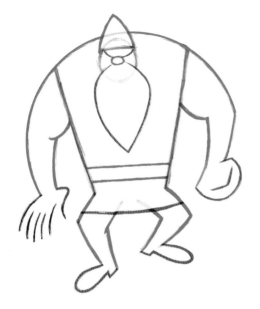
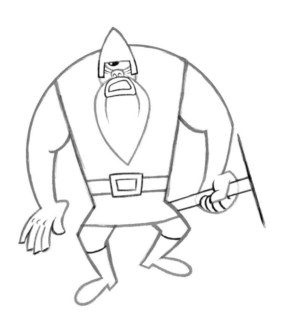
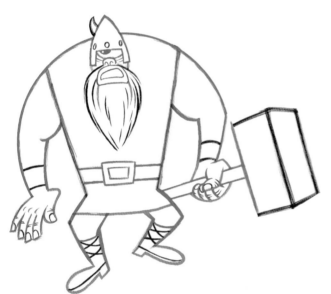

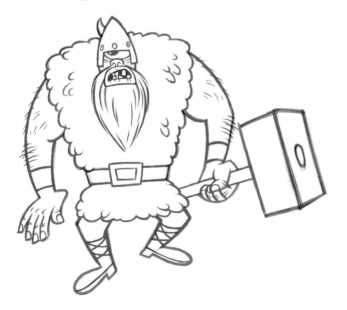
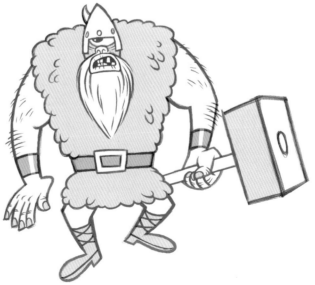

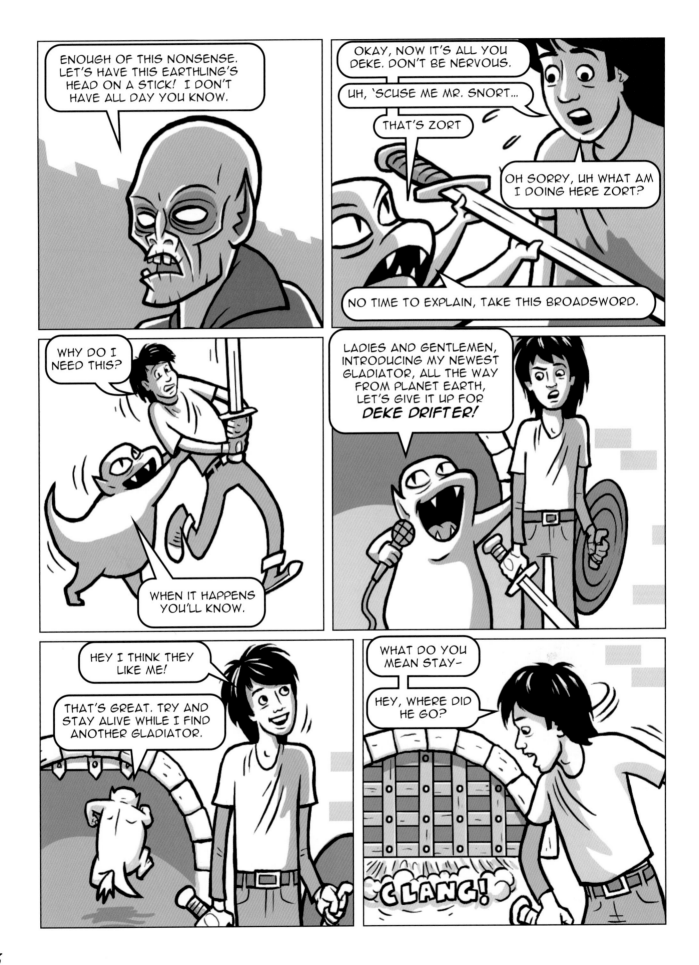

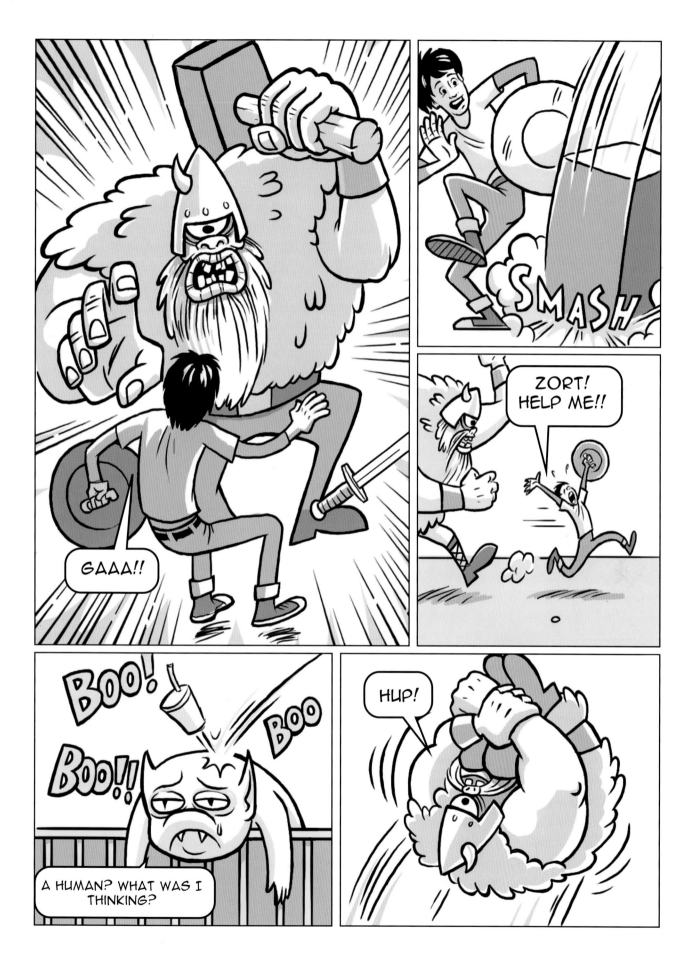

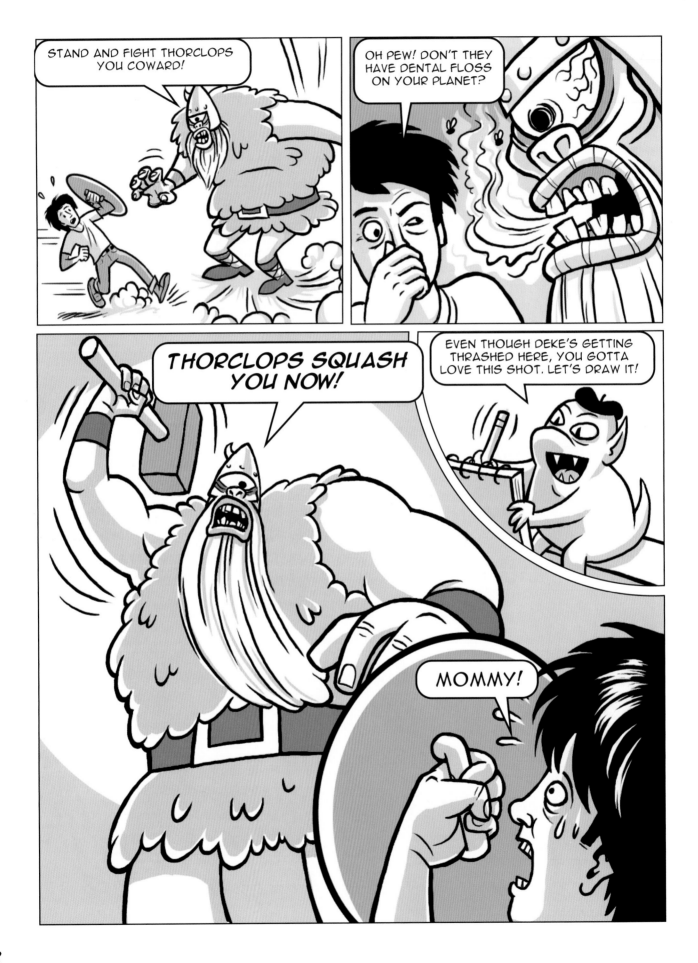

NOTES ABOUT FORESHORTENING

FORESHORTENING HAPPENS WHEN SOMETHING LONG IS POINTING STRAIGHT AT YOU AND THE LENGTH IS HIDDEN. IF YOU'RE DRAWING A LITTLE GUY WITH SHORT ARMS KEEP THE HAND SMALL.

BUT WITH A BIG GUY WITH LONG ARMS, MAKE THE HAND MUCH BIGGER. IT INCREASES THE FORESHORTENING EFFECT.

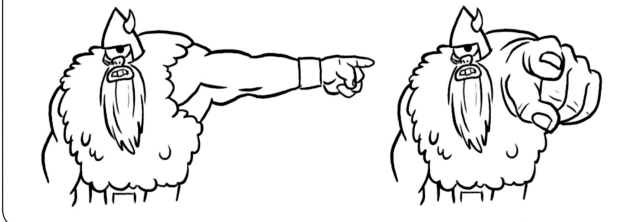

START ON A SLIGHT ANGLE.

DRAW THESE LINES LIGHTLY, THEY WILL BE ERASED LATER.

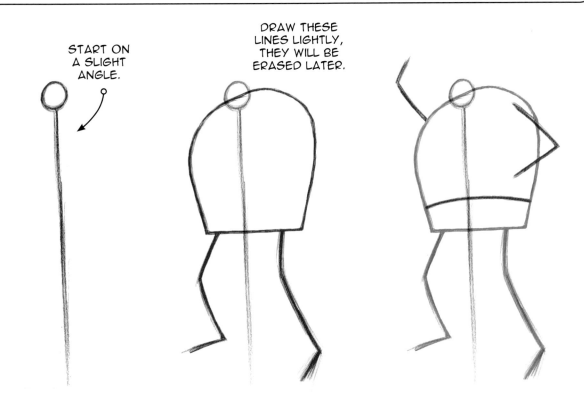

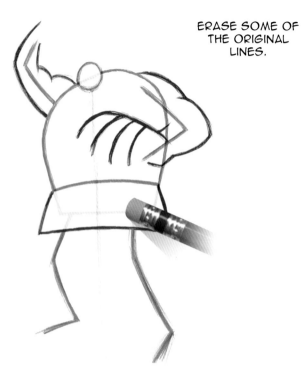

ERASE SOME OF
THE ORIGINAL
LINES.

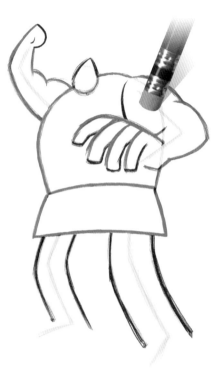

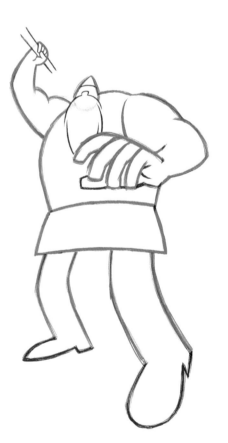

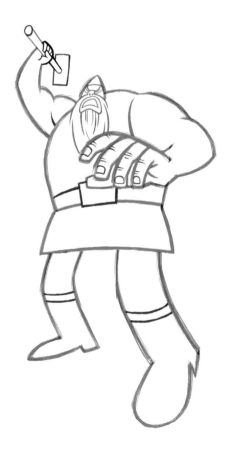

LIGHTEN THE ORIGINAL OUTLINE OF HIS
COAT WITH YOUR ERASER. ADD THE FUR;
THEN ERASE THE LINE COMPLETELY.

THE MIGHTY THORCLOPS HAMMER,
A MAGICAL WEAPON THAT IS SAID
TO ALWAYS RETURN TO THE HAND
AFTER IT HAD BEEN THROWN.

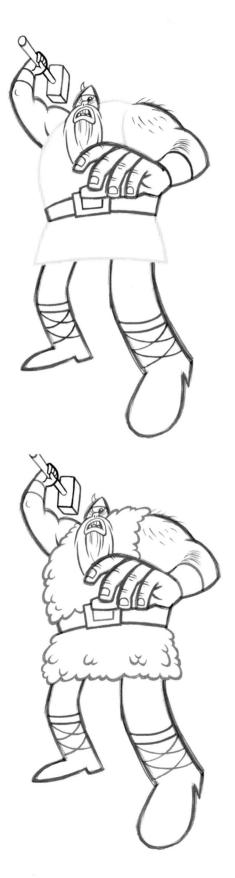

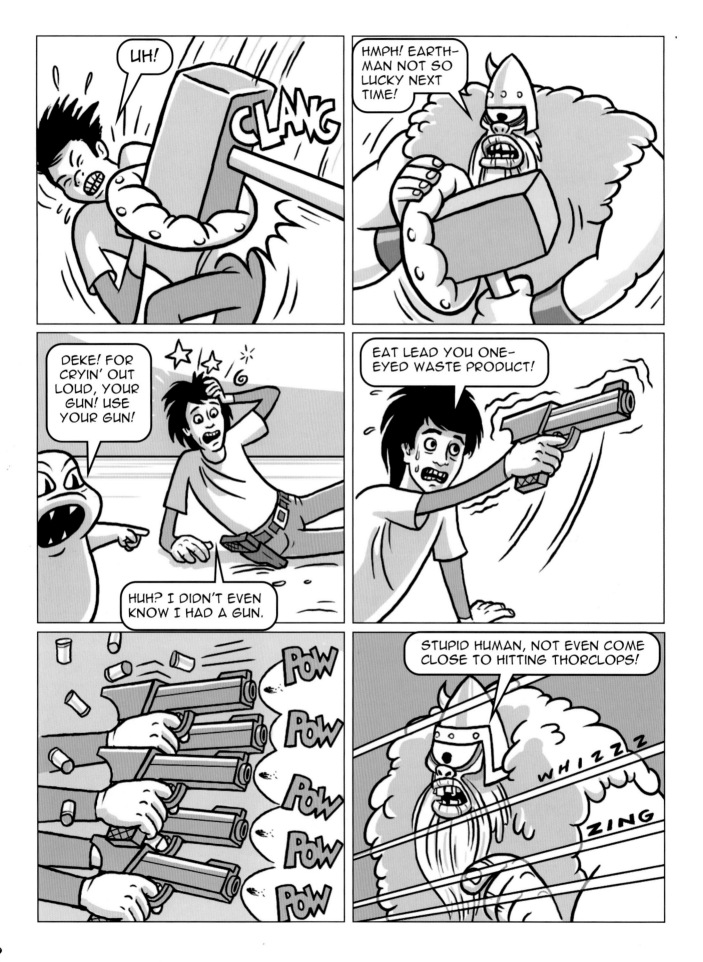

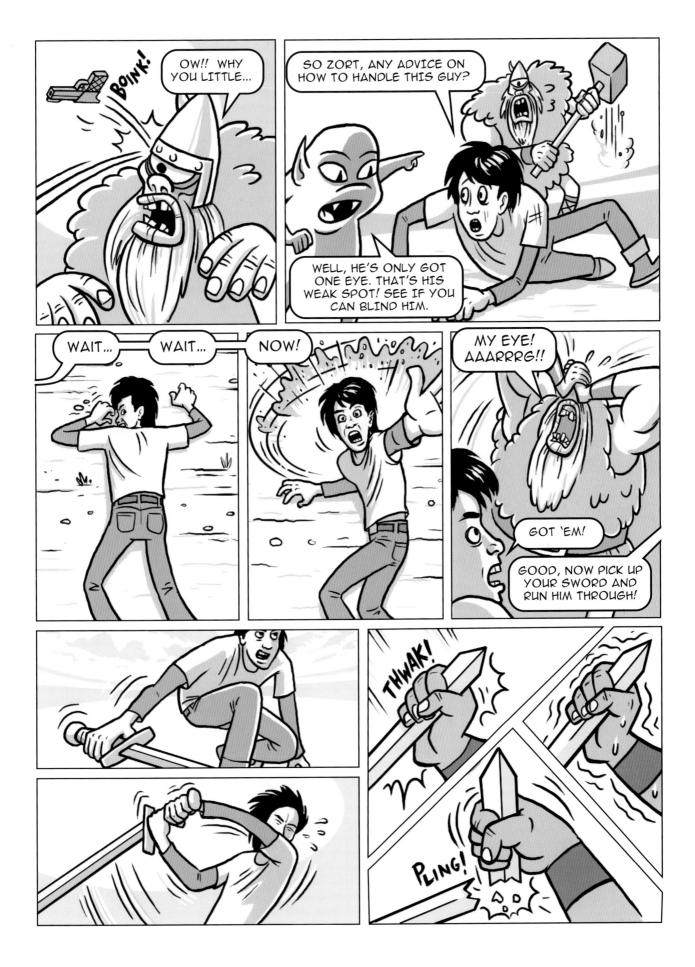

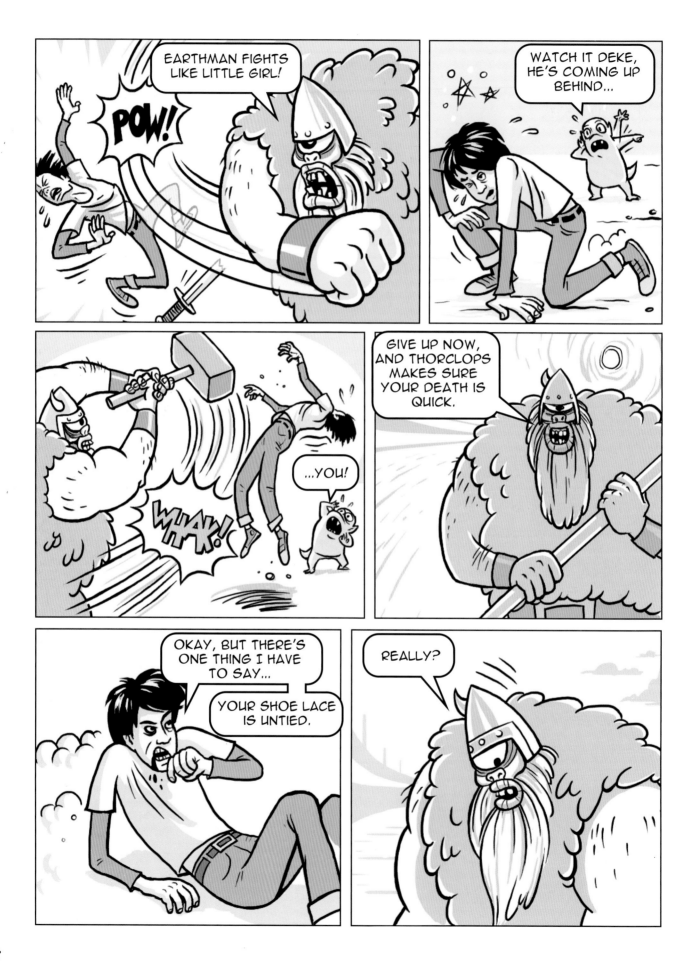

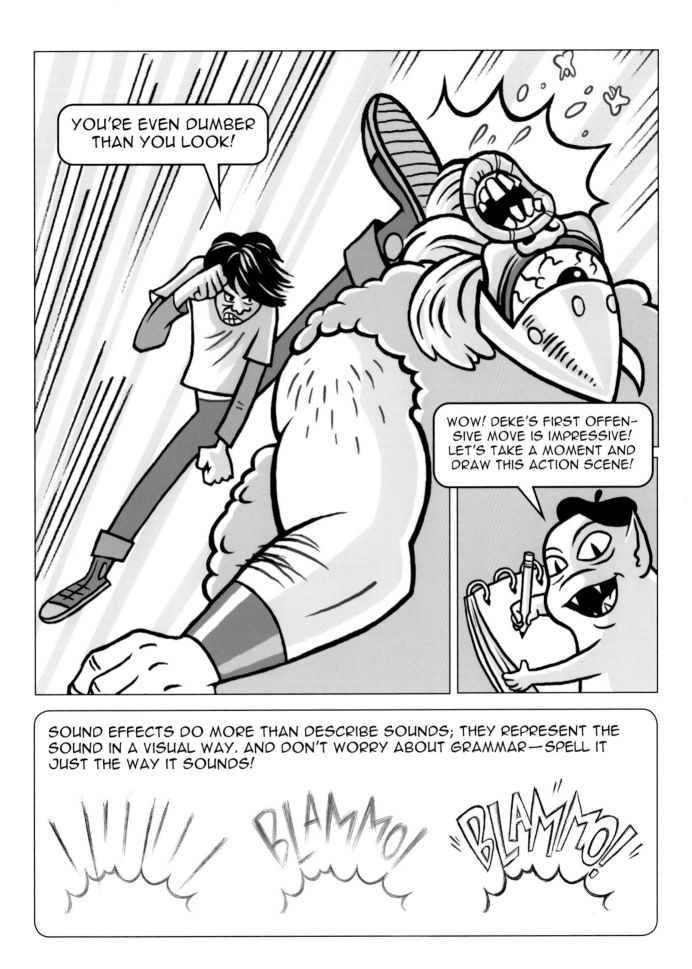

SOUND EFFECTS DO MORE THAN DESCRIBE SOUNDS; THEY REPRESENT THE SOUND IN A VISUAL WAY. AND DON'T WORRY ABOUT GRAMMAR—SPELL IT JUST THE WAY IT SOUNDS!

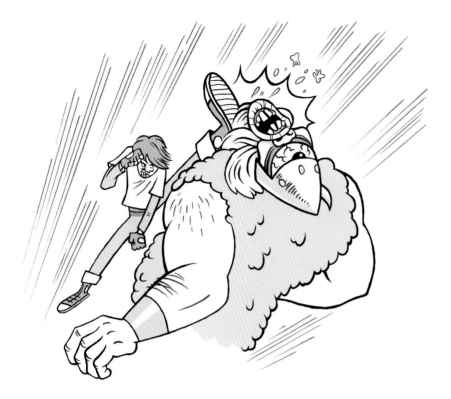

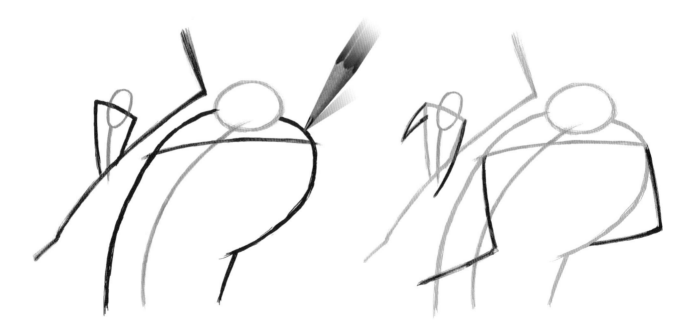

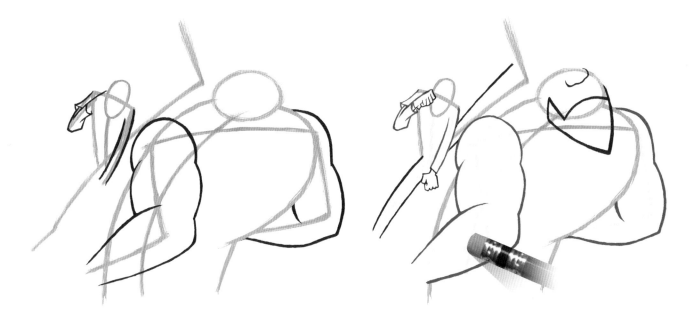

ERASE SOME OF
THE ORIGINAL LINES.

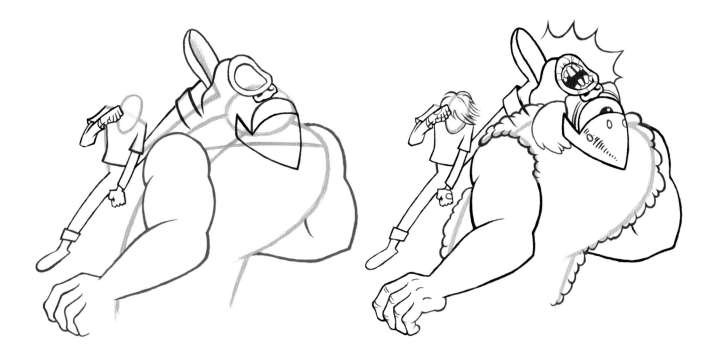

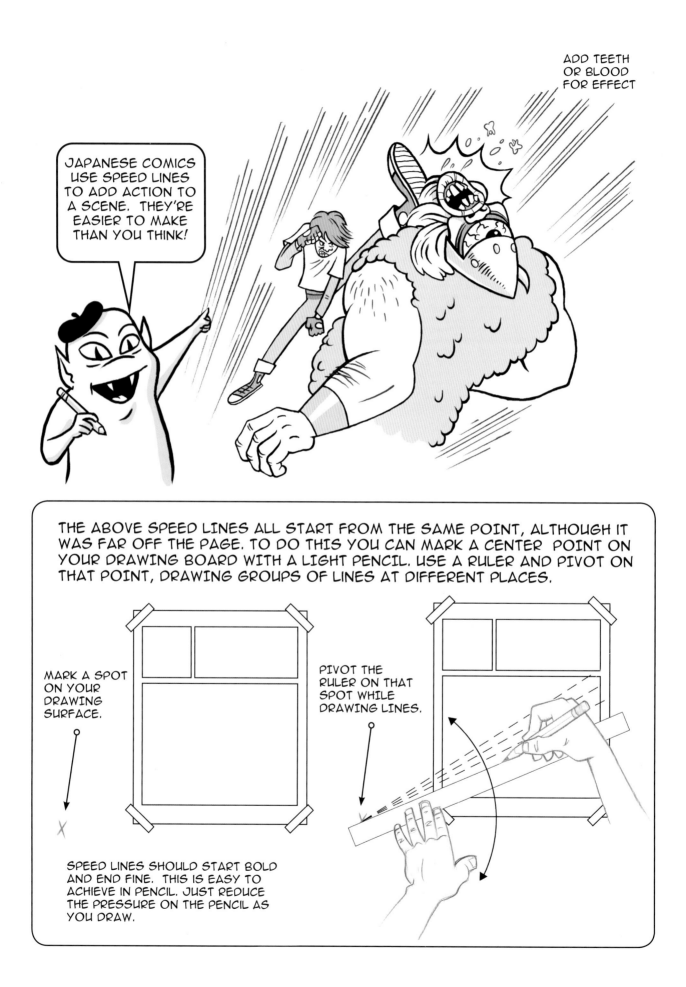

ADD TEETH
OR BLOOD
FOR EFFECT

JAPANESE COMICS USE SPEED LINES TO ADD ACTION TO A SCENE. THEY'RE EASIER TO MAKE THAN YOU THINK!

THE ABOVE SPEED LINES ALL START FROM THE SAME POINT, ALTHOUGH IT WAS FAR OFF THE PAGE. TO DO THIS YOU CAN MARK A CENTER POINT ON YOUR DRAWING BOARD WITH A LIGHT PENCIL. USE A RULER AND PIVOT ON THAT POINT, DRAWING GROUPS OF LINES AT DIFFERENT PLACES.

MARK A SPOT ON YOUR DRAWING SURFACE.

PIVOT THE RULER ON THAT SPOT WHILE DRAWING LINES.

SPEED LINES SHOULD START BOLD AND END FINE. THIS IS EASY TO ACHIEVE IN PENCIL. JUST REDUCE THE PRESSURE ON THE PENCIL AS YOU DRAW.

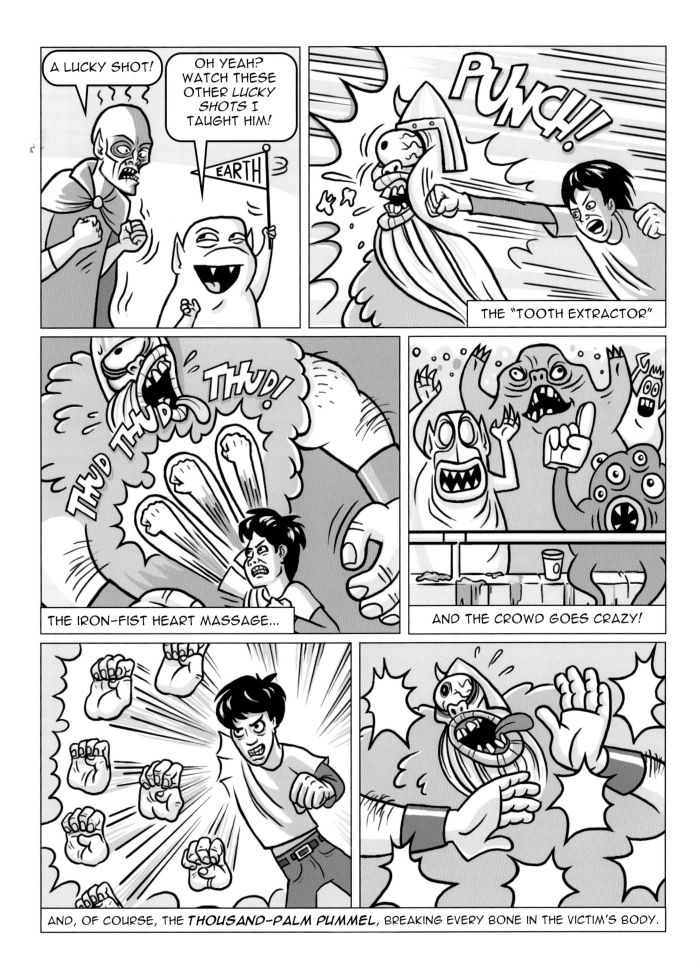

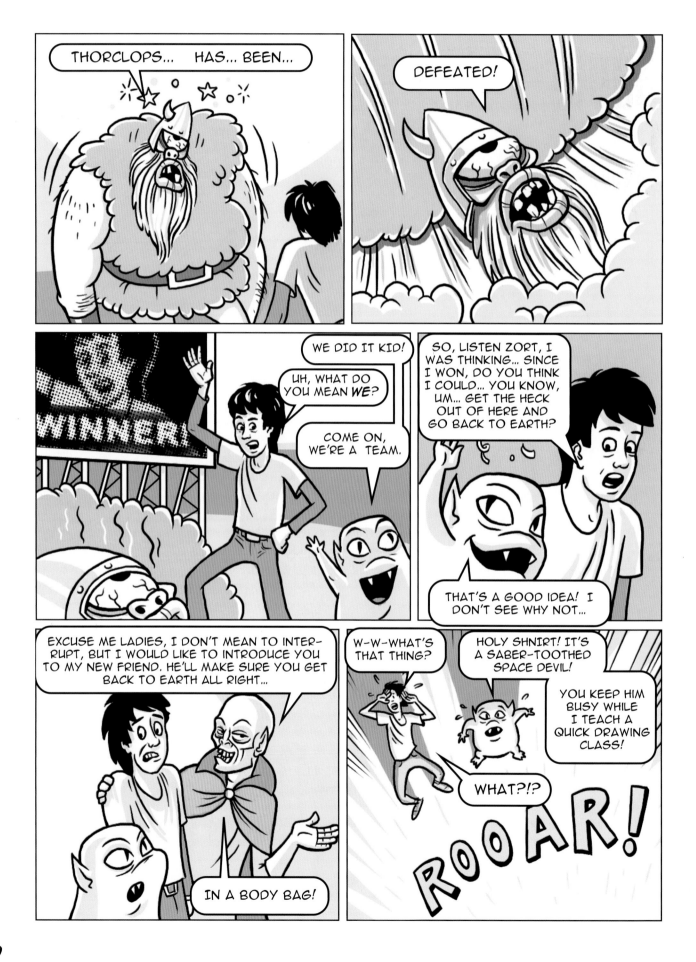

Saber-Toothed Space Devil

THIS CREATURE IS EVERY BIT AS TERRIFYING AS IT SOUNDS. HE COMES FROM THE DISTANT ANDROMEDA GALAXY AND STANDS A MASSIVE 25 FEET TALLER THAN HIS HUMAN OPPONENT. IF HIS RAZOR-SHARP FANGS DON'T TEAR YOU IN HALF, HIS GIANT CLUBBED TAIL WILL KNOCK YOU SENSELESS. HIS RAVENOUS APPETITE IS HIS ONLY WEAKNESS. TRY AND USE THAT TO YOUR ADVANTAGE.

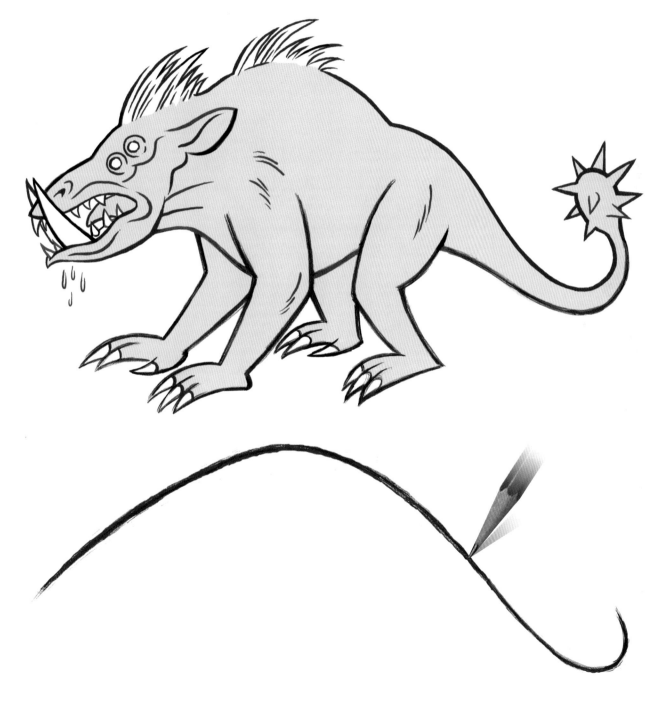

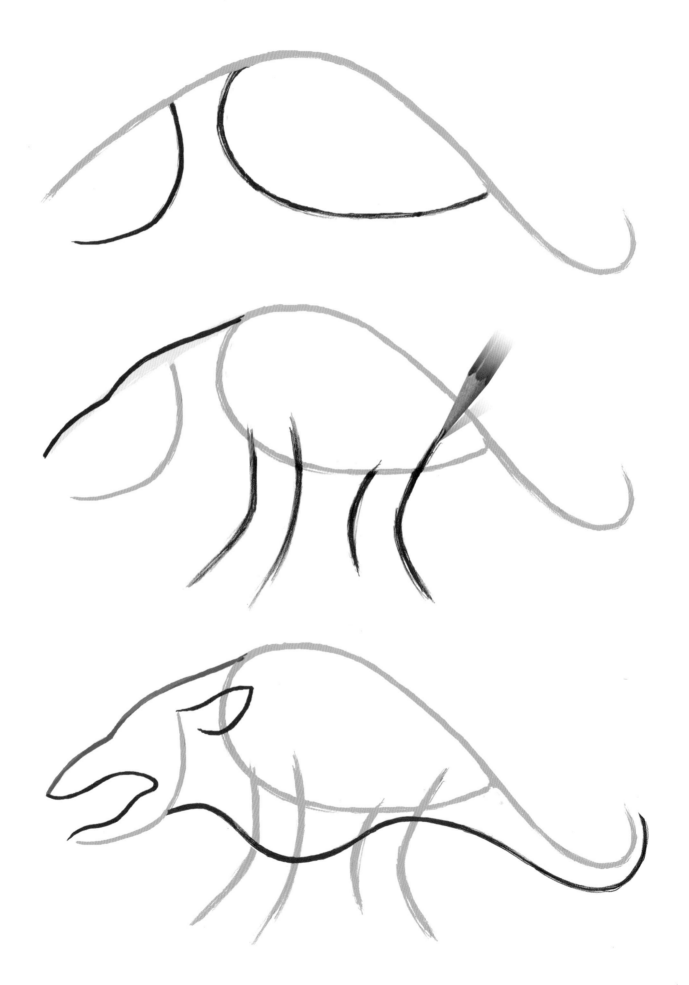

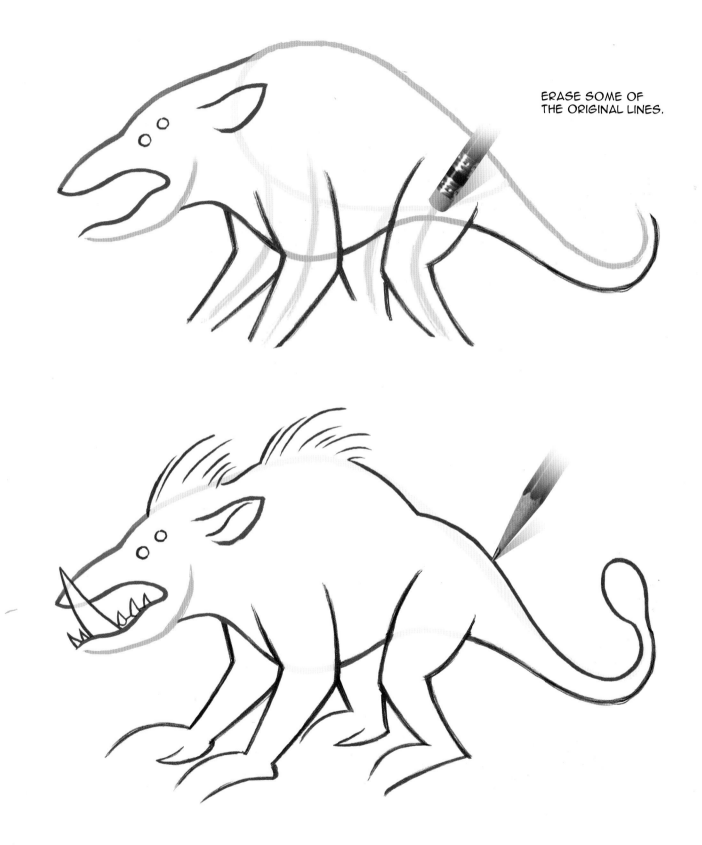

ERASE SOME OF
THE ORIGINAL LINES.

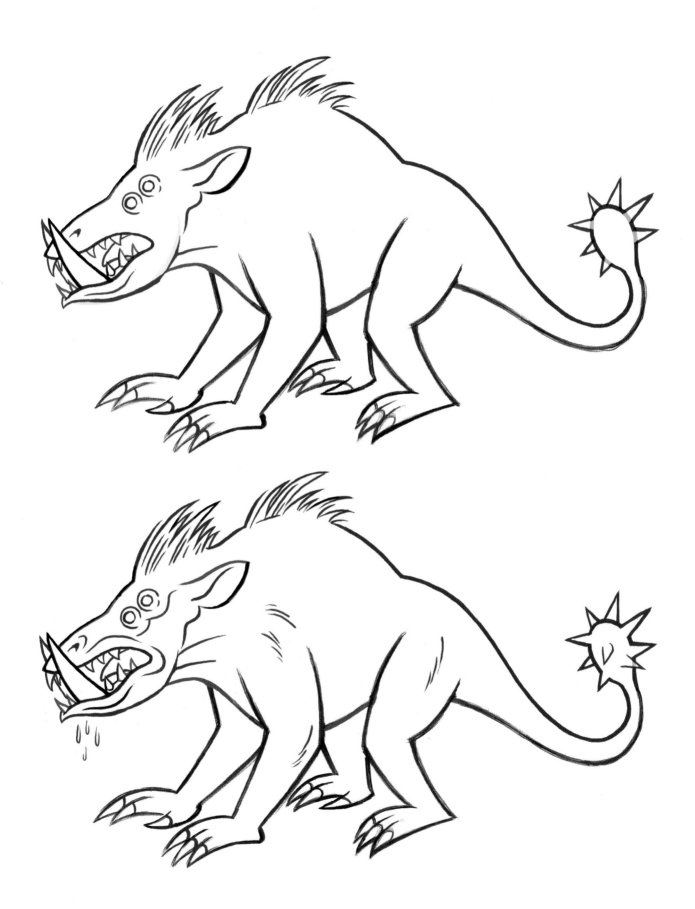

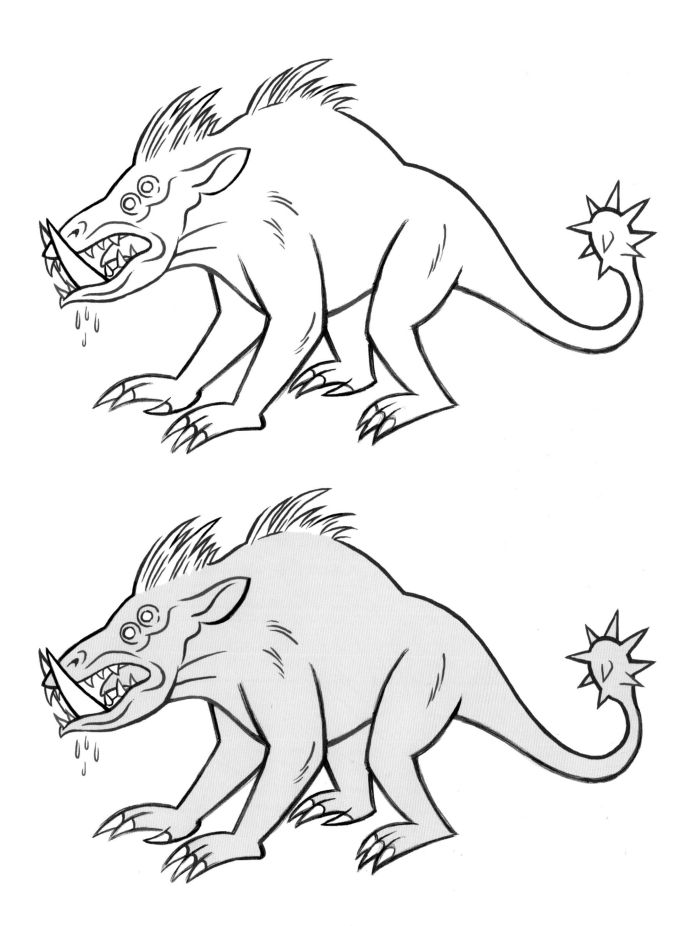

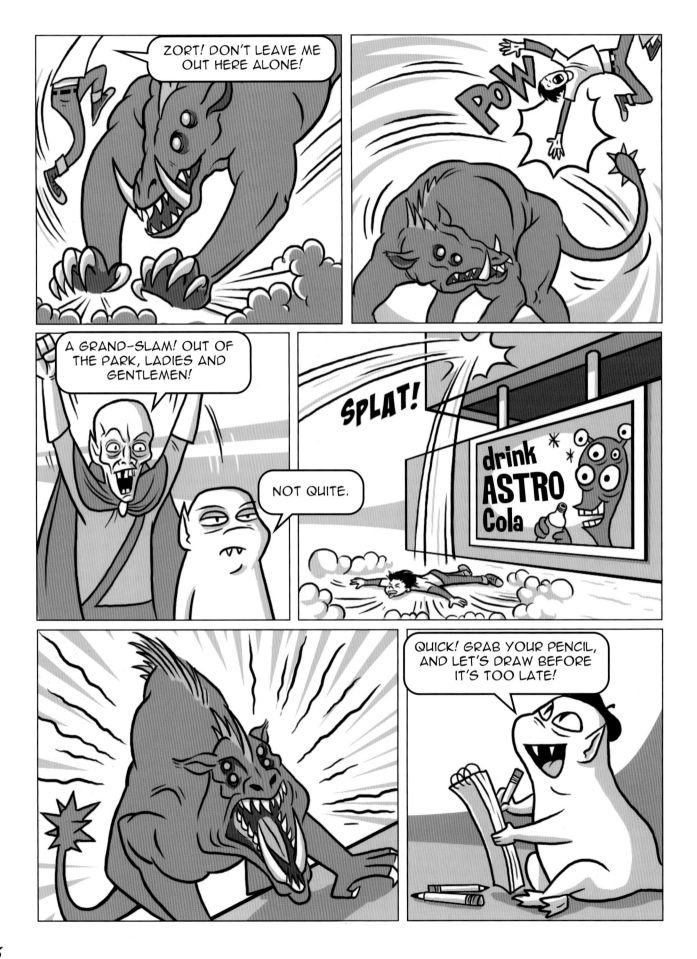

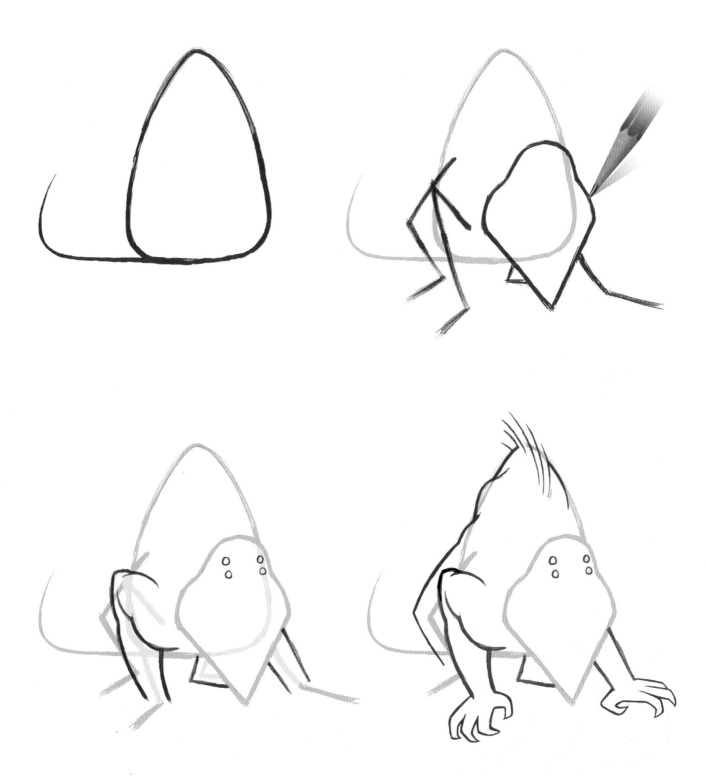

 AS YOU ALREADY KNOW, DRAWING PENCILS COST MONEY. DON'T THROW THE LITTLE STUBS AWAY. INSTEAD, GET YOURSELF A PENCIL EXTENDER TO GET THE MOST OUT OF EVERY ONE OF THOSE SUCKERS!

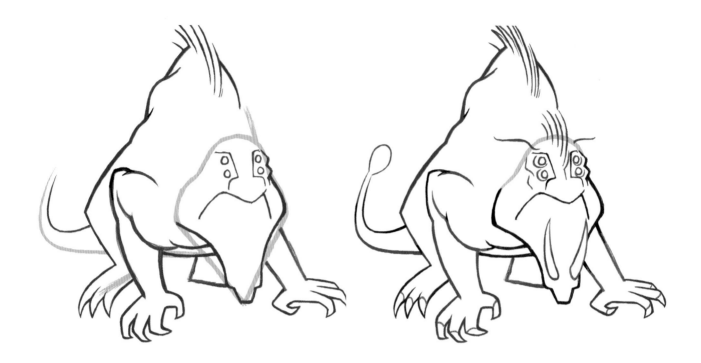

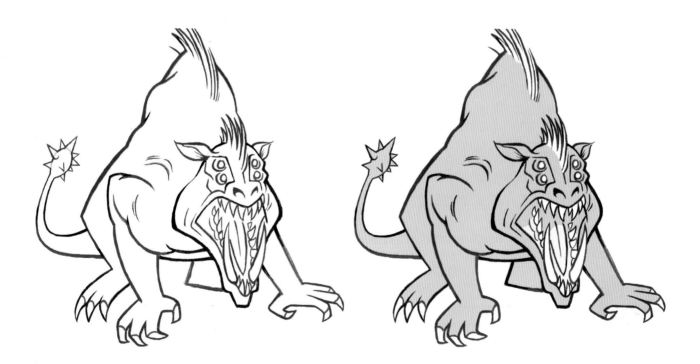

38

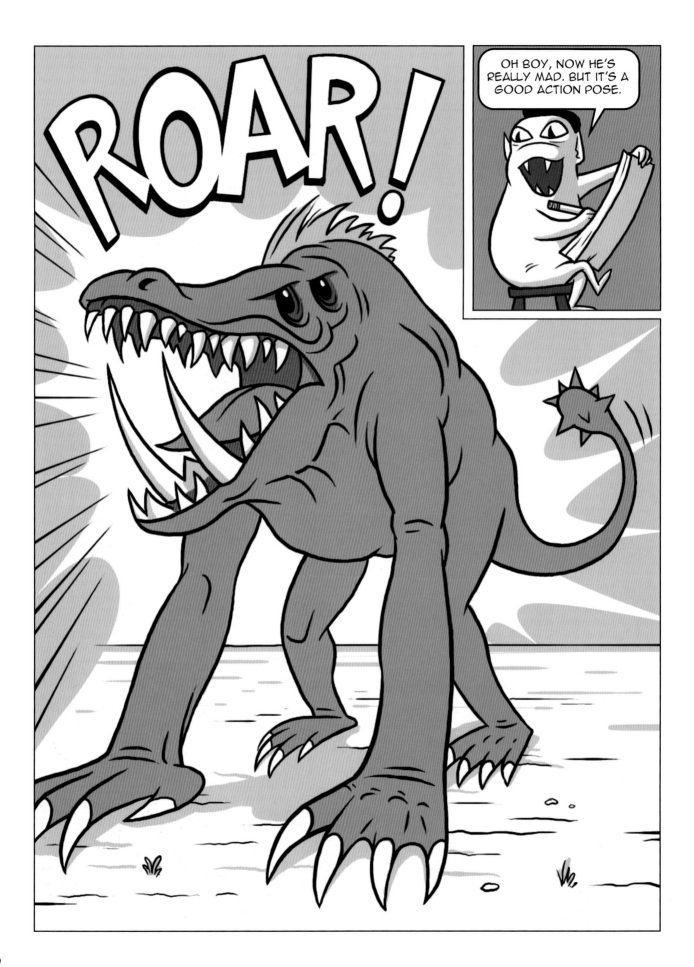

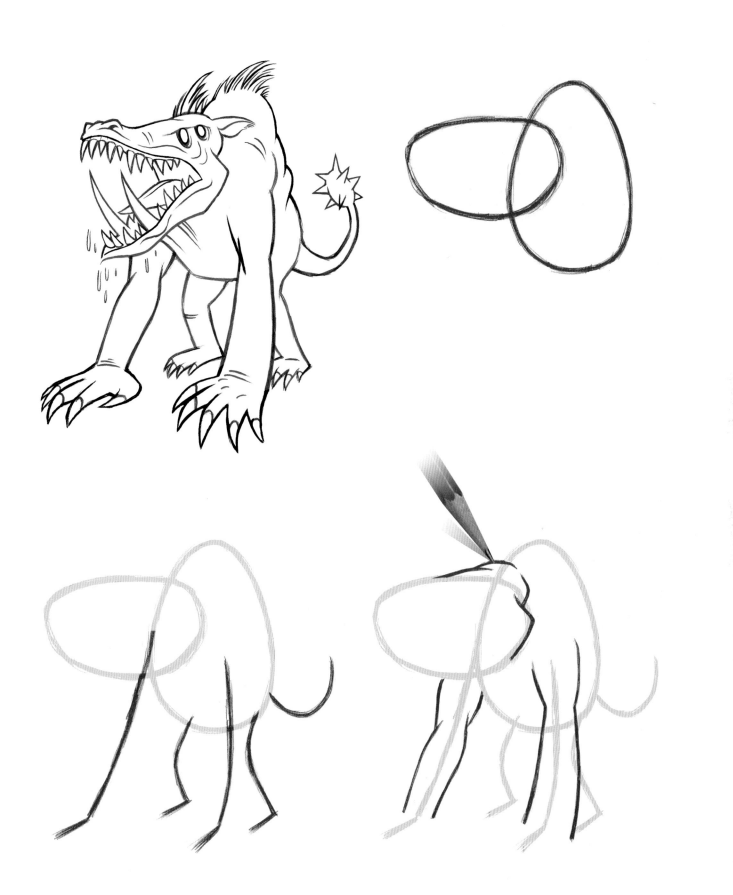

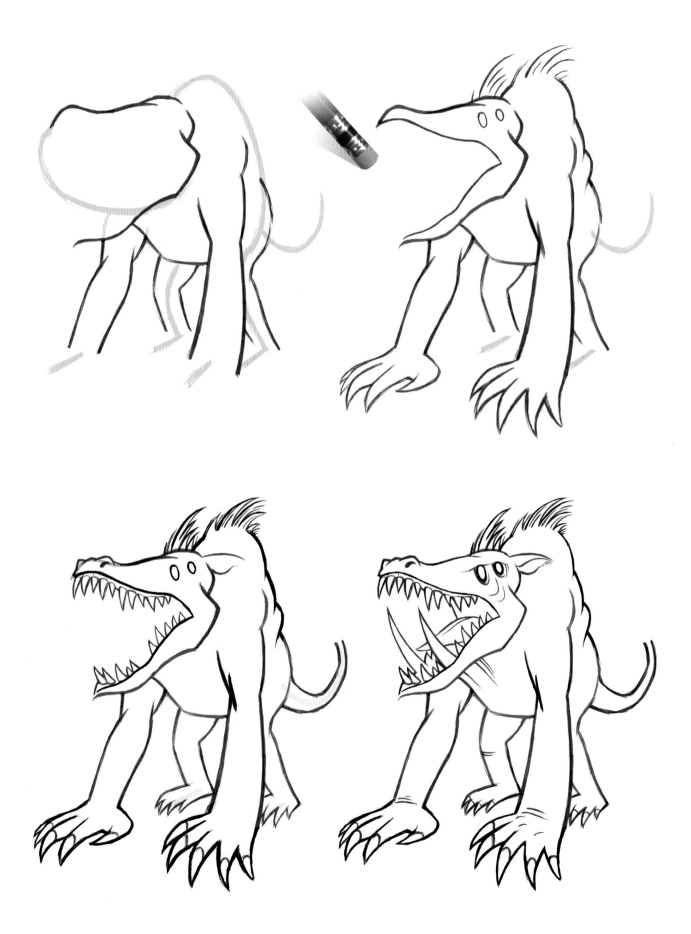

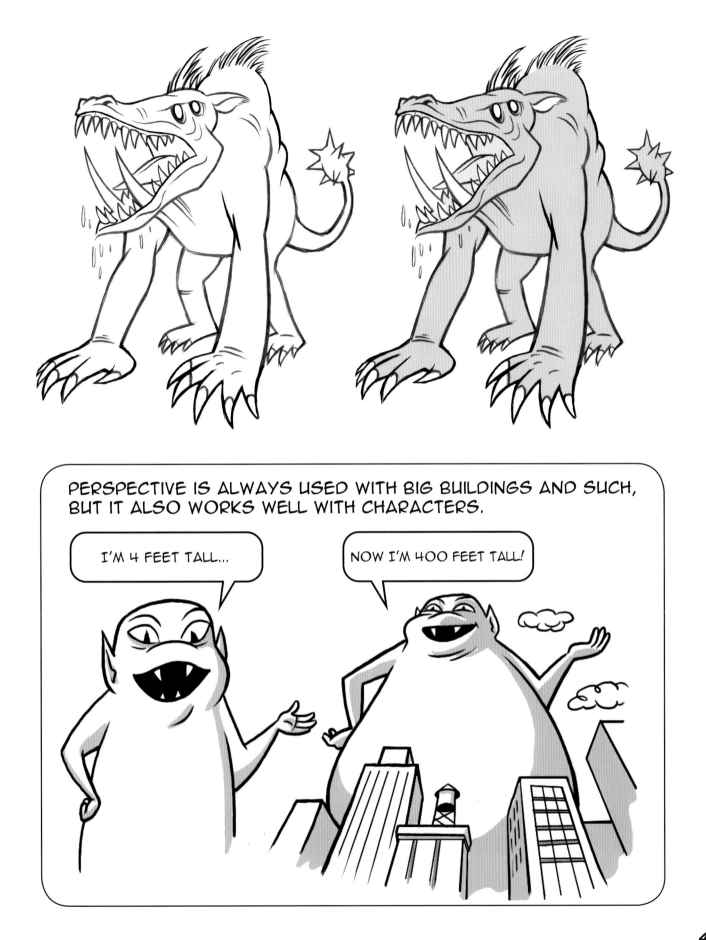

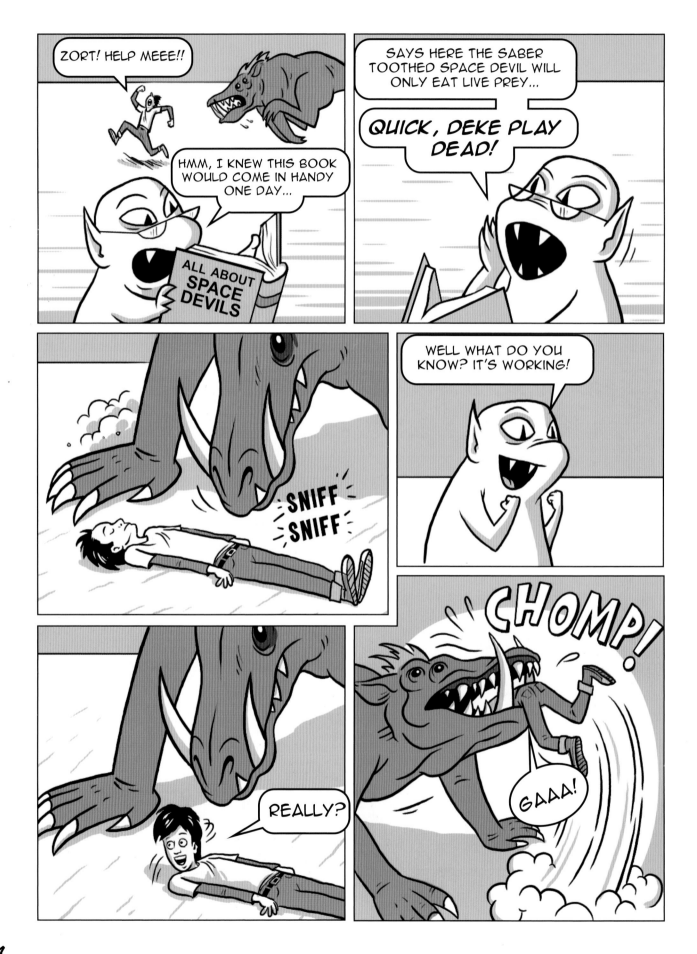

44

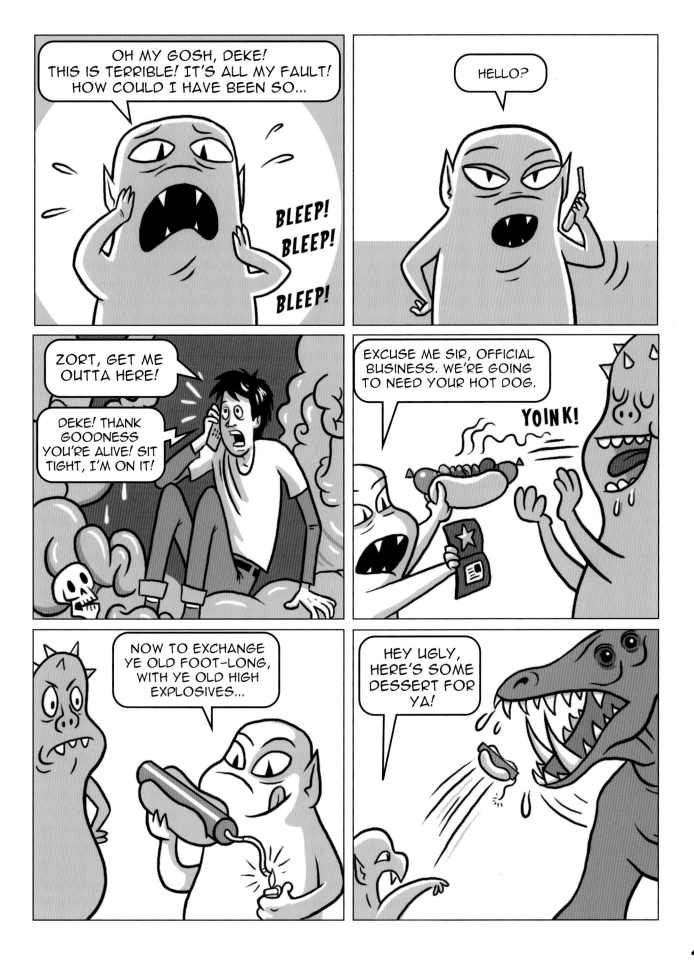

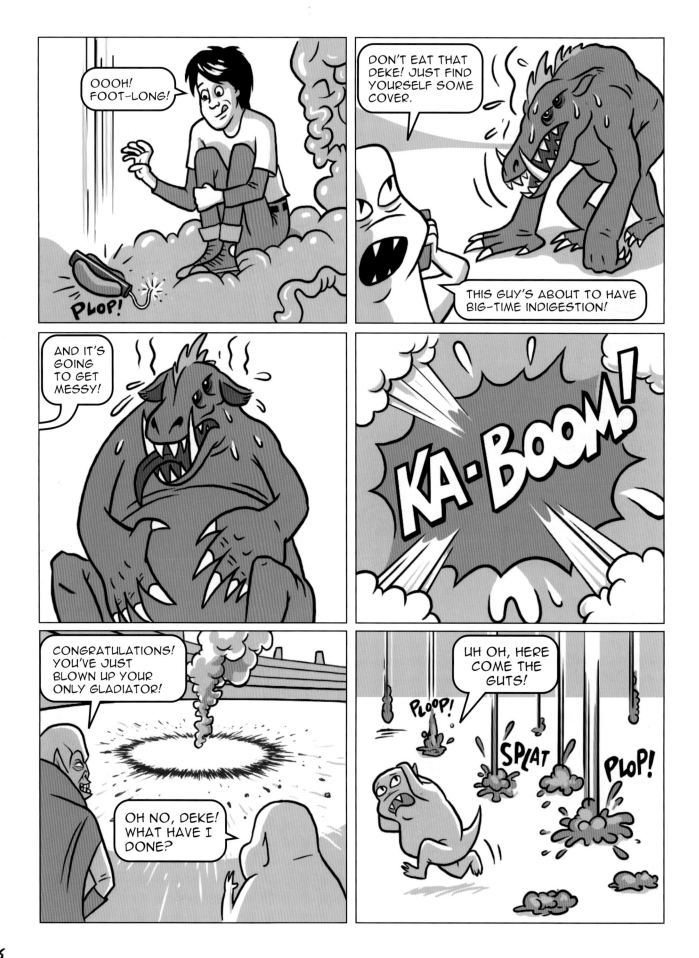

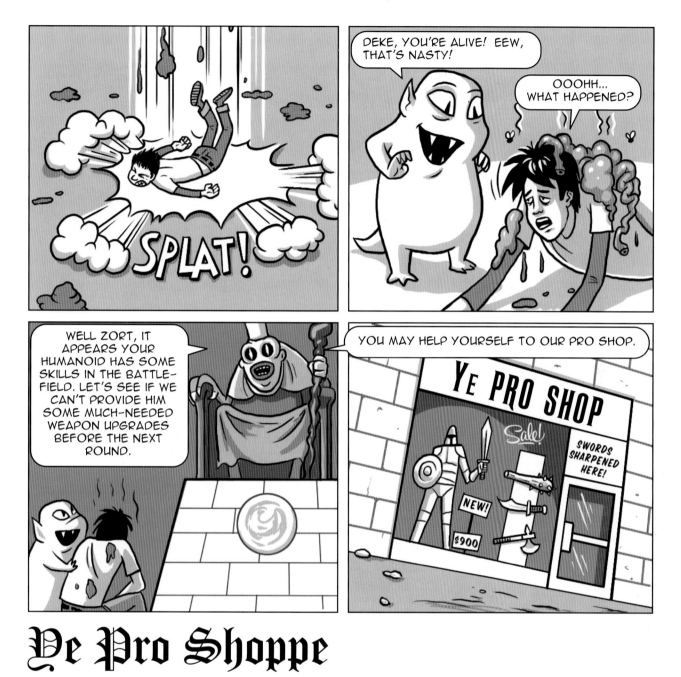

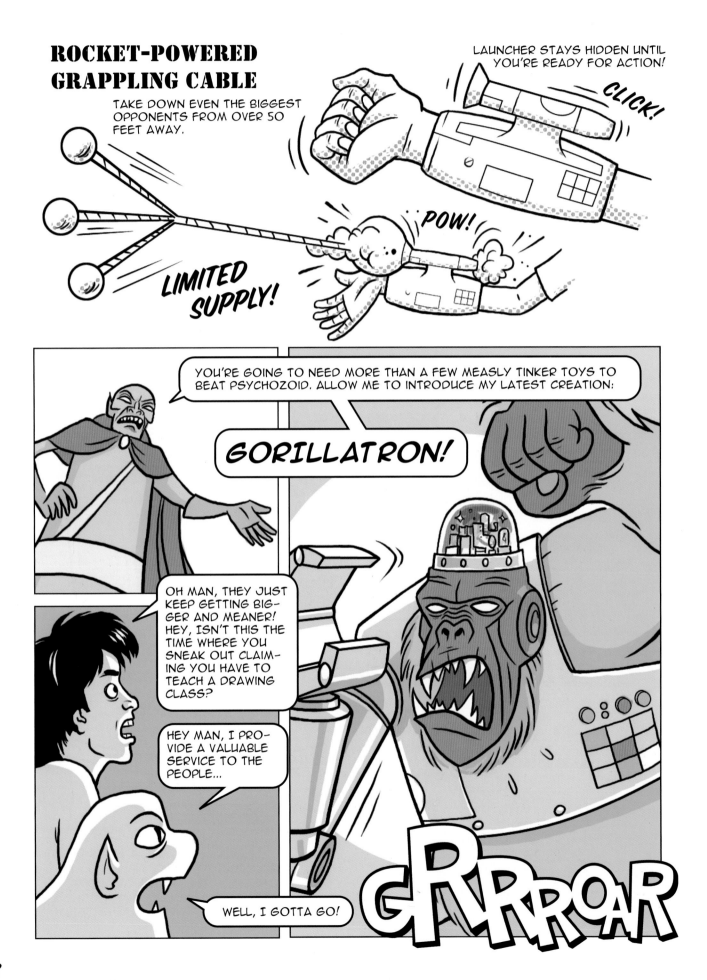

Gorillatron

HALF BEAST, HALF MACHINE, THE GORILLATRON IS A SCIENCE EXPERIMENT GONE HORRIBLY WRONG. IN AN ATTEMPT TO CREATE THE MOST ADVANCED CYBORG WARRIOR, PSYCHOZOID SKIMPED ON SOME VITAL COMPONENTS AND THE RESULT WAS THIS 6,000-POUND NIGHTMARE! THE GORIL- LATRON IS A POTENT KILLING MACHINE, BUT HIS POSITRONIC BRAIN IS CROSS-WIRED AND FULL OF BUGS. YOU MUST OUTSMART THIS MONSTER BECAUSE YOU WILL NEVER OVERPOWER IT.

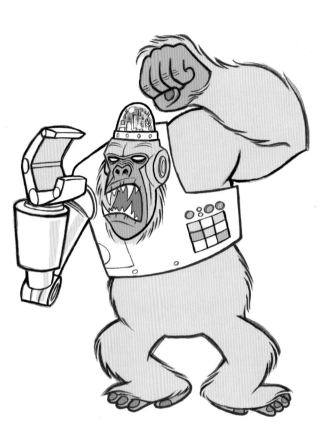

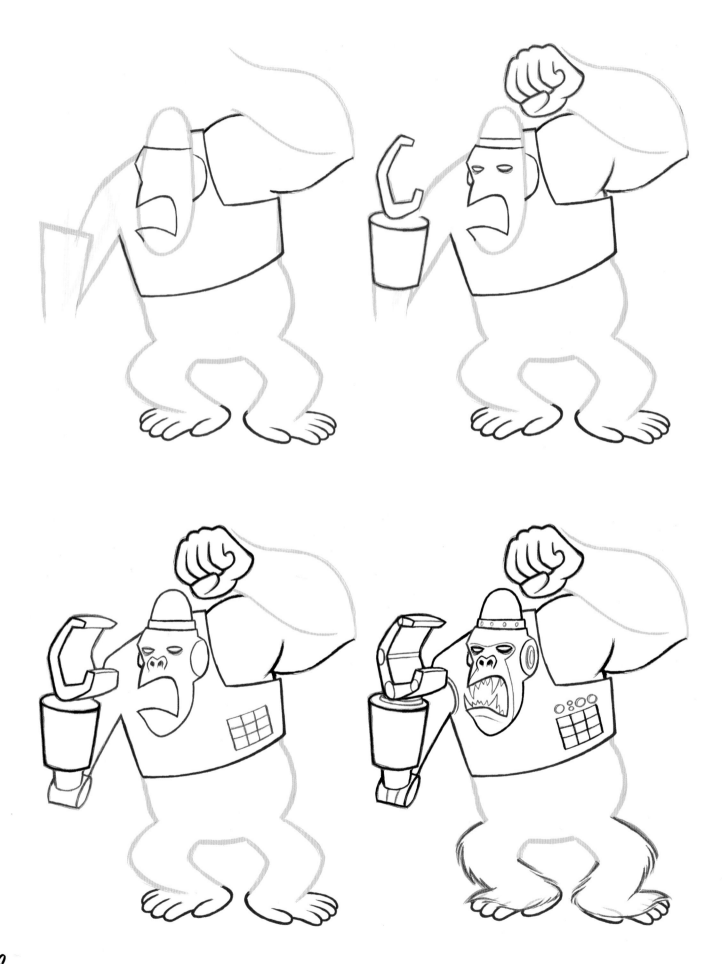

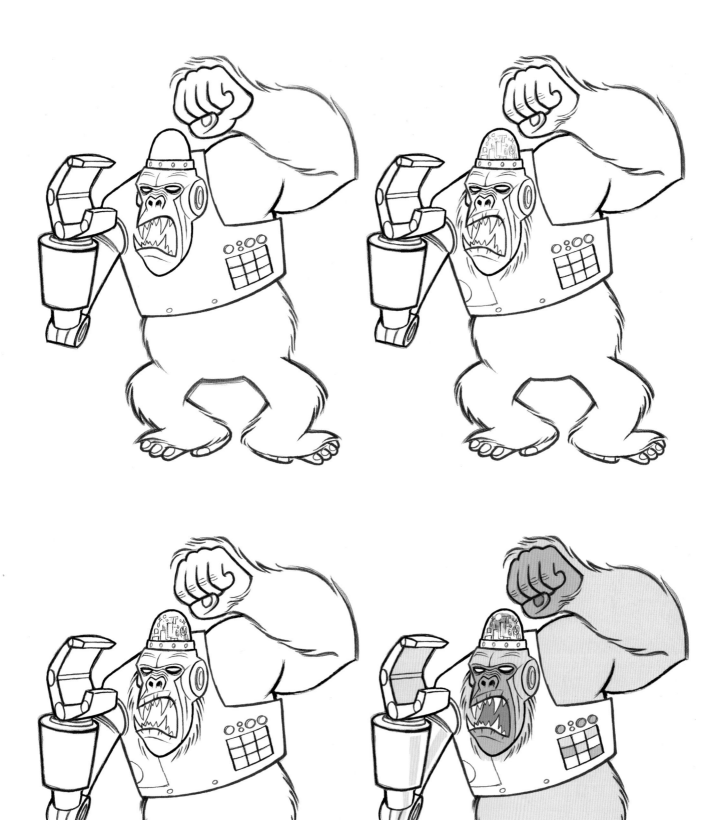

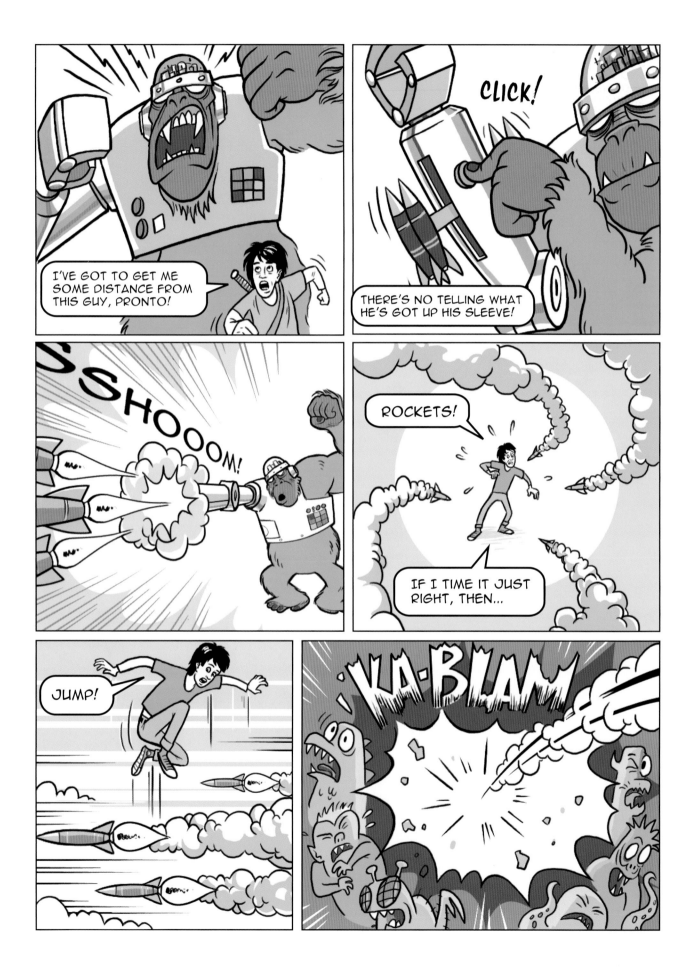

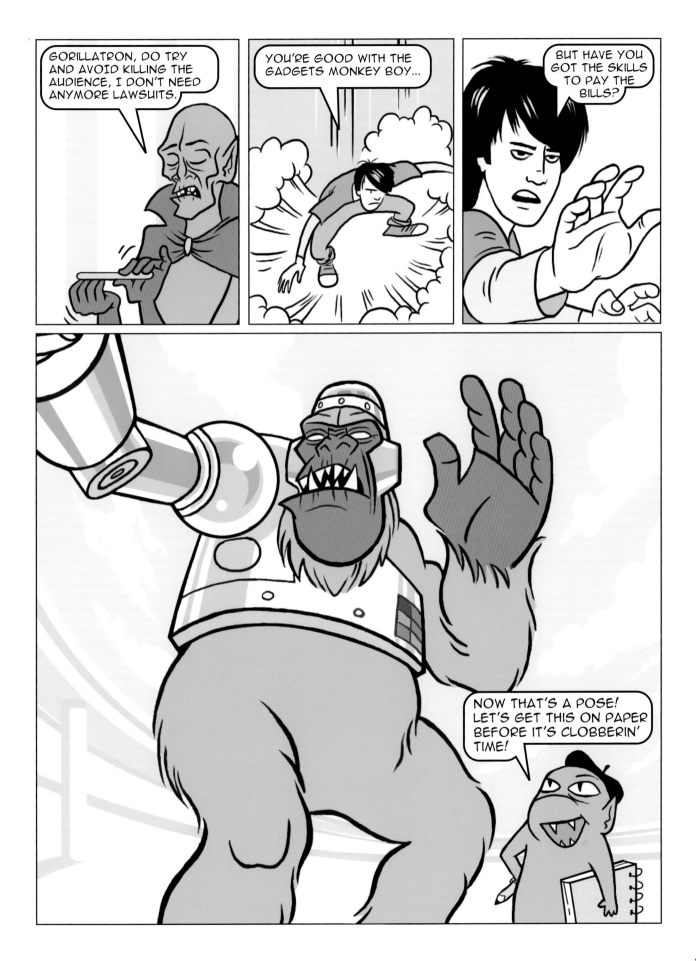

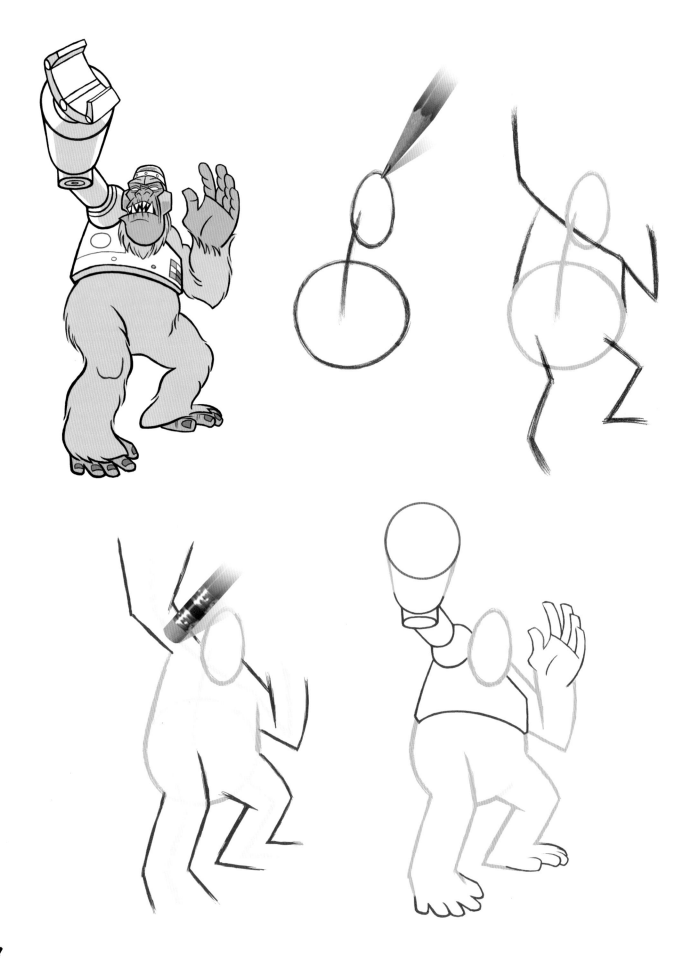

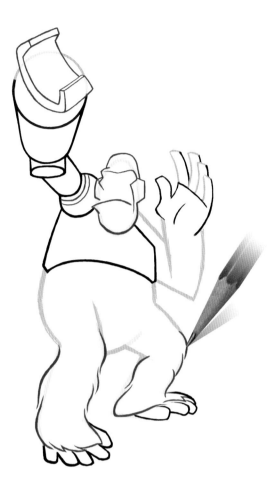

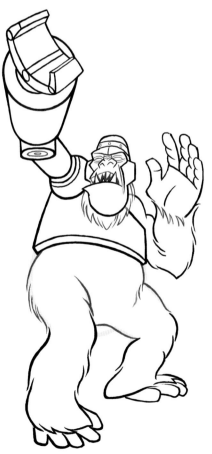

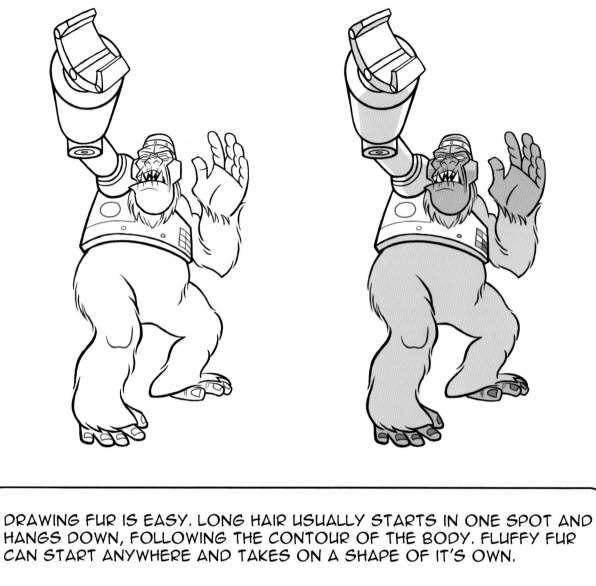

DRAWING FUR IS EASY. LONG HAIR USUALLY STARTS IN ONE SPOT AND HANGS DOWN, FOLLOWING THE CONTOUR OF THE BODY. FLUFFY FUR CAN START ANYWHERE AND TAKES ON A SHAPE OF IT'S OWN.

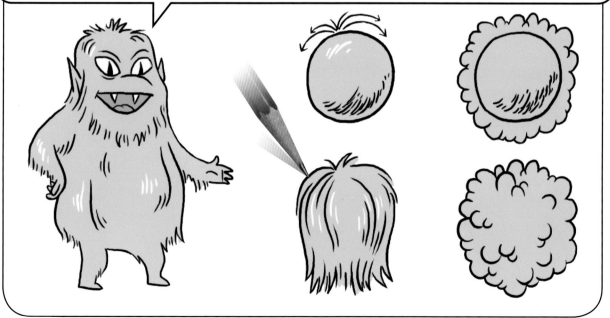

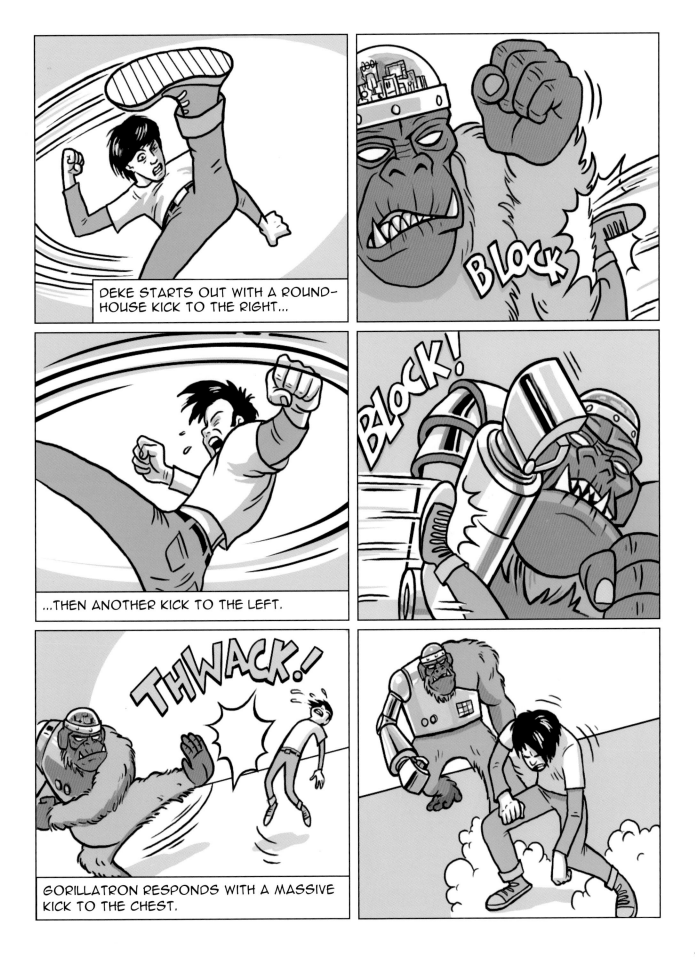

DEKE STARTS OUT WITH A ROUND-HOUSE KICK TO THE RIGHT...

...THEN ANOTHER KICK TO THE LEFT.

GORILLATRON RESPONDS WITH A MASSIVE KICK TO THE CHEST.

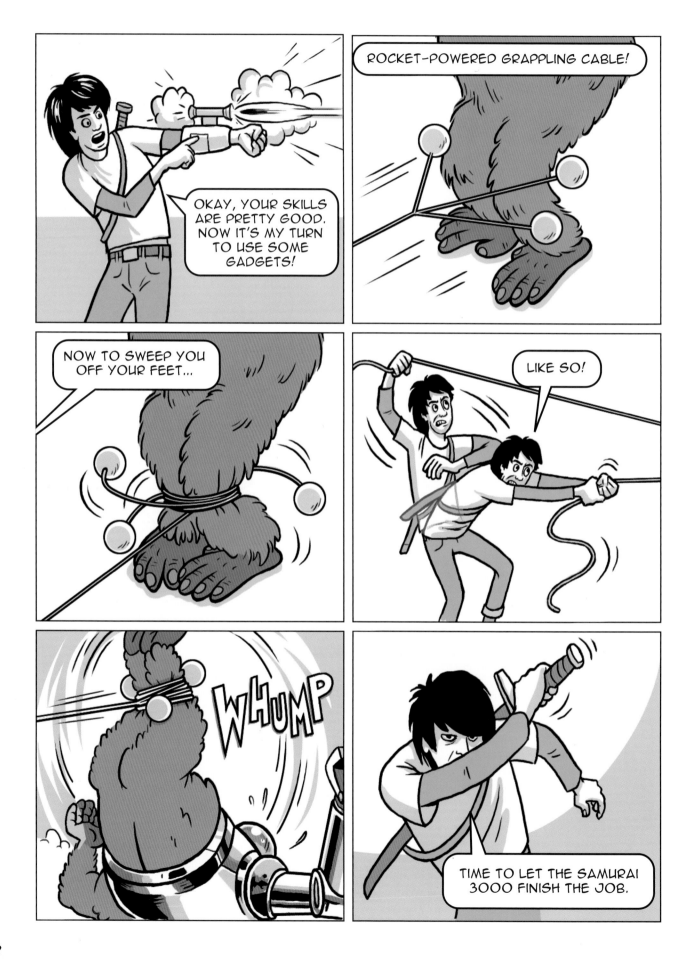

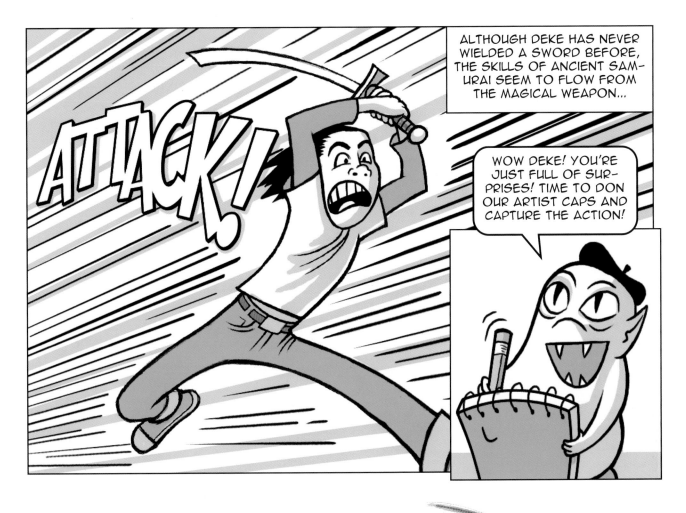

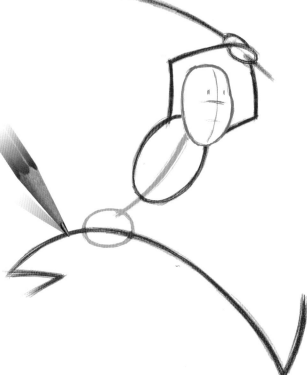

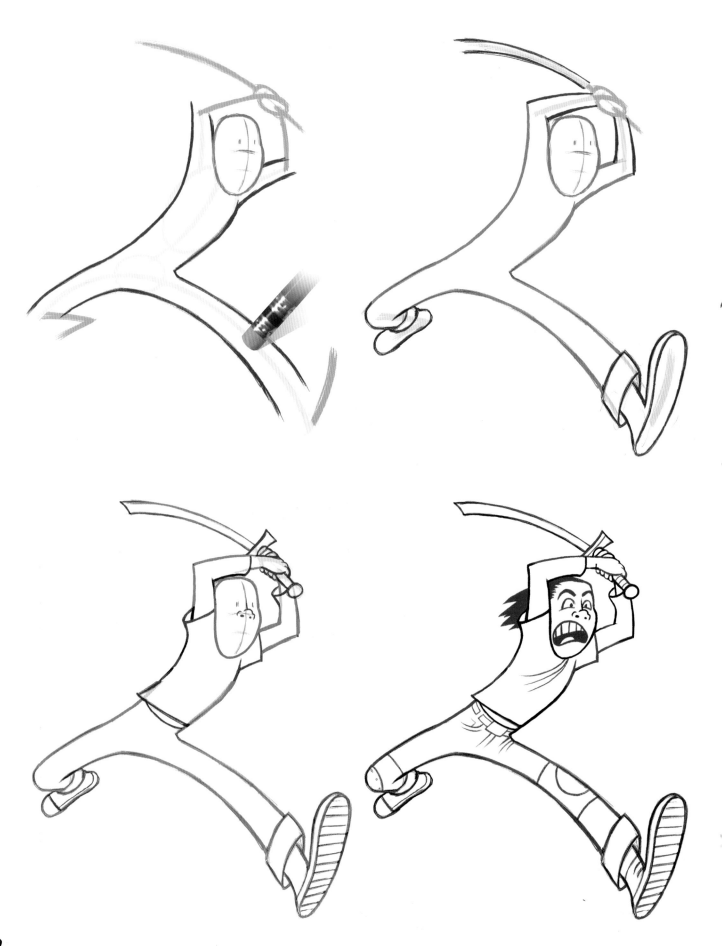

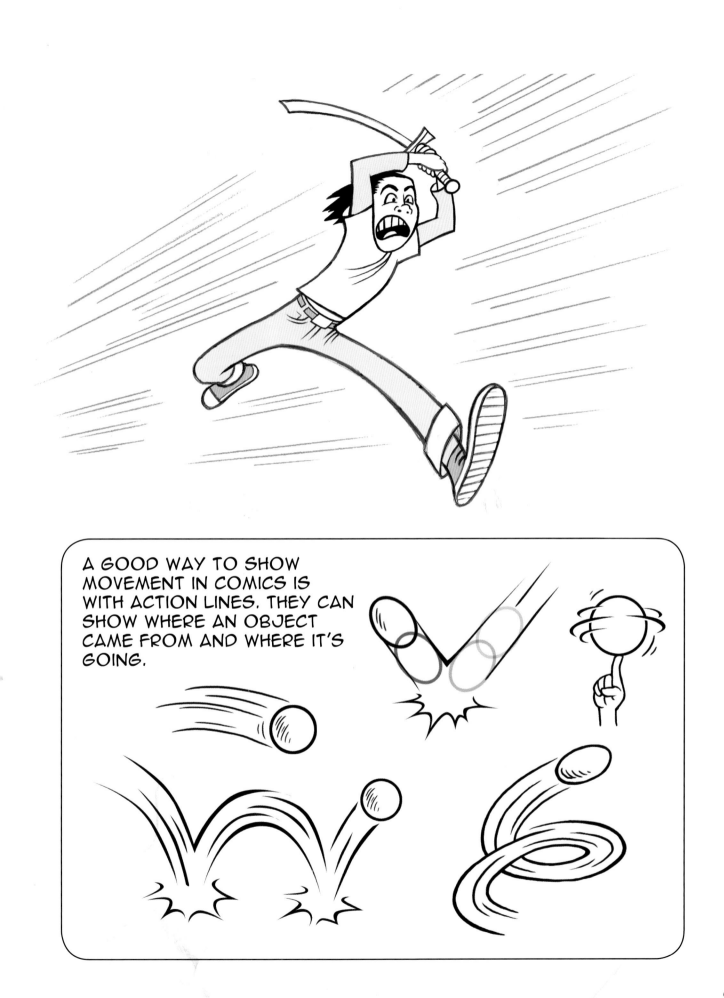

A GOOD WAY TO SHOW MOVEMENT IN COMICS IS WITH ACTION LINES. THEY CAN SHOW WHERE AN OBJECT CAME FROM AND WHERE IT'S GOING.

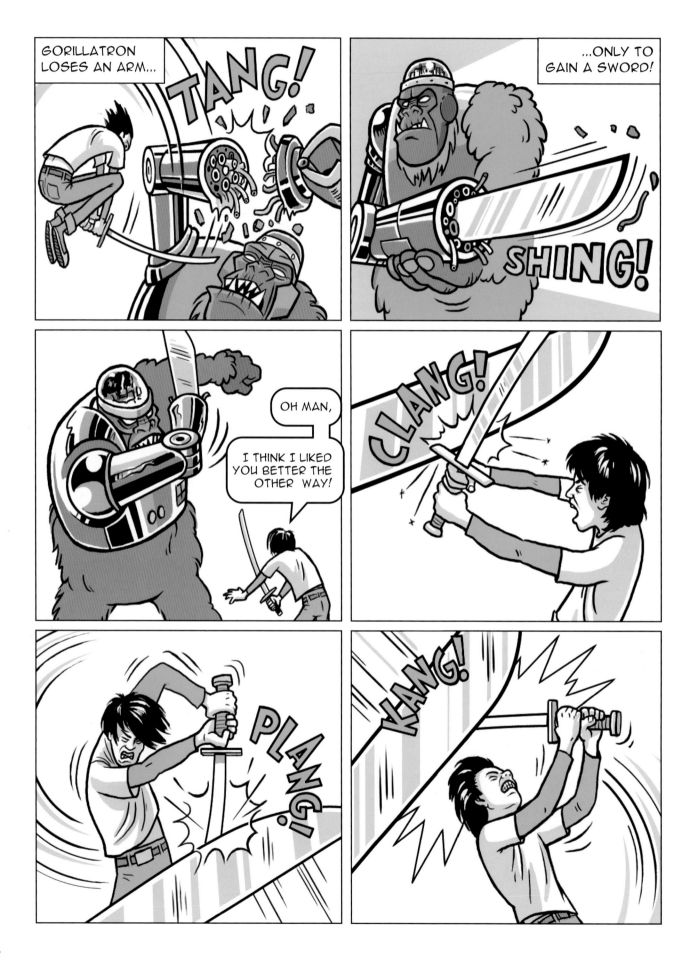

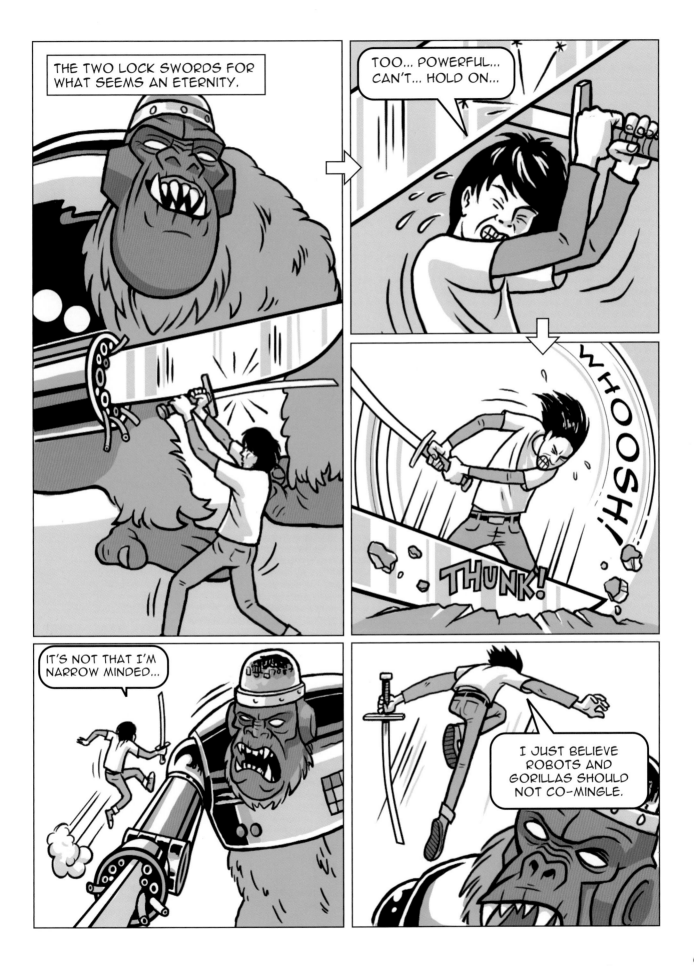

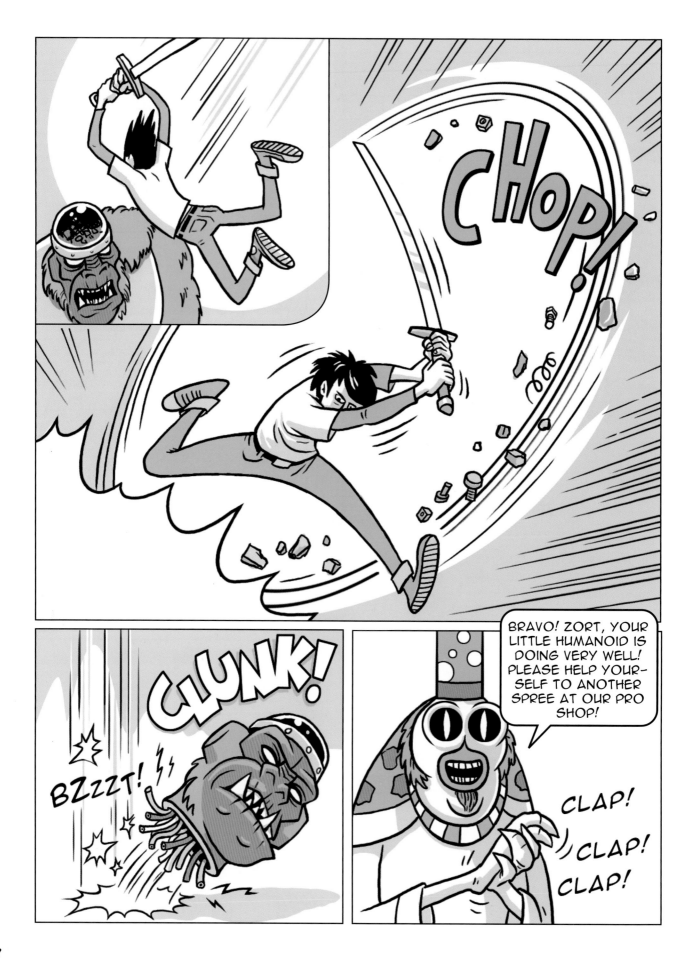

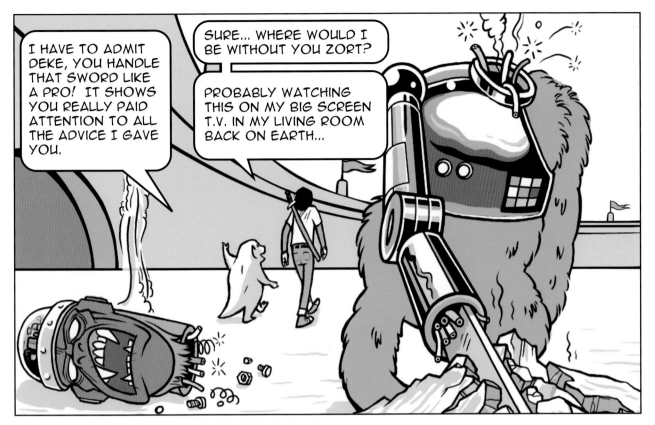

Ye Pro Shoppe

FREEZE GRENADE

Gift Pack!

HAND-HELD BALLISTIC DEVICE WILL ENCASE ENTIRE PERIMETER IN SOLID ICE!

PERSONAL JET PACK

SPECIAL

STRANDED ON A LIFELESS PLANET FOR ETERNITY? NOT TO WORRY; MAKE THE JUMP TO HYPER-SPACE WITH THIS LIGHT-WEIGHT PERSONAL PROPULSION UNIT!

1 MEGATON MINI-NUKE

WHY FUSS WITH A 'DIRTY BOMB' WHEN YOU CAN HAVE THE REAL THING?

FORCE FIELD 'IN A RING'

NEW!

VOICE-ACTIVATED MAGNOTRONIC SHIELD PROVIDES HIGH LEVEL OF PROTECTION IN A HANDSOME RING. OUR BEST SELLER!

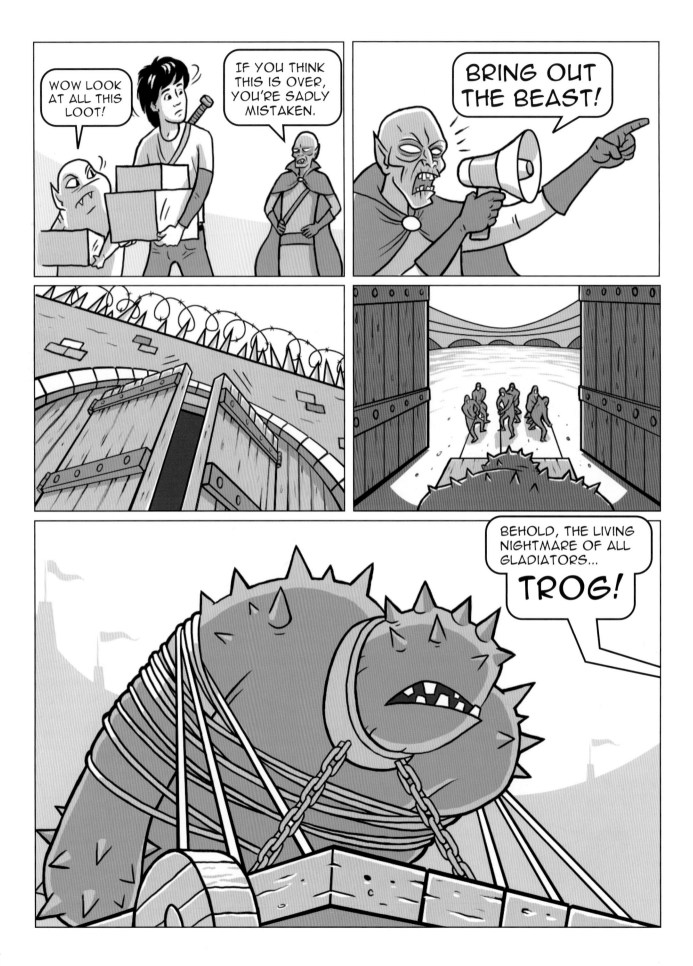

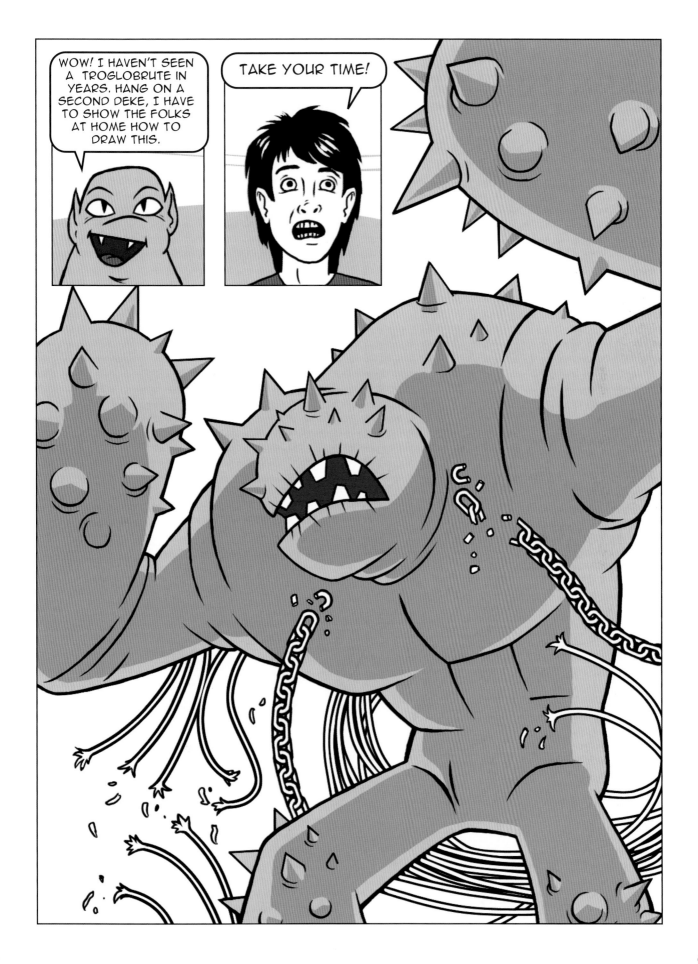

67

Troglobrute

THE TROGLOBRUTE, OR 'TROG,' IS MORE CAPTIVE SLAVE THAN GLADIATOR. HIS DISMAL LIFE IS SPENT TORMENTED AND TAUNTED UNTIL ITS RAGE REACHES EXPLOSIVE LEVELS. IT'S THEN RELEASED INTO THE ARENA WITH A VIOLENT FURY FEW OPPONENTS LIVE TO TELL ABOUT. THE TROG'S EXTERIOR IS MADE OF SOLID ROCK, AND ALTHOUGH IT HAS NO EYES, IT USES GAMMA RAYS TO DETECT ITS OPPONENT.

COMIC ARTISTS OFTEN USE 'NON-PHOTO BLUE' PENCIL FOR ROUGH SKETCHES. IT DIS-APPEARS WHEN PHOTOCOPIED.

NON-PHOTO BLUE PENCIL

DARK PENCIL OR INK

PHOTO COPY

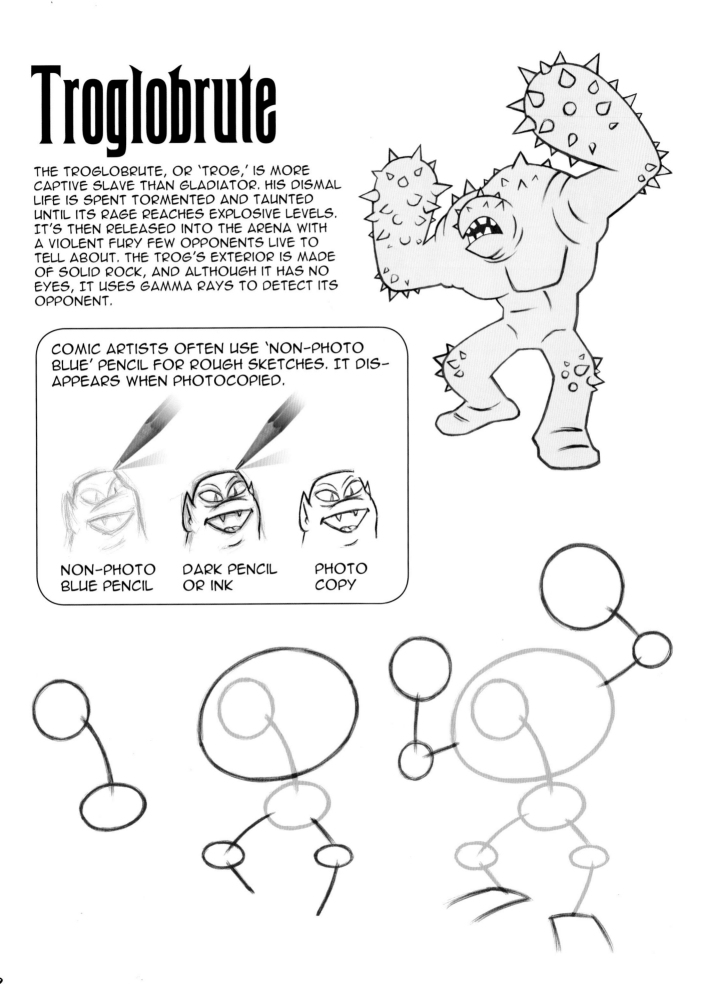

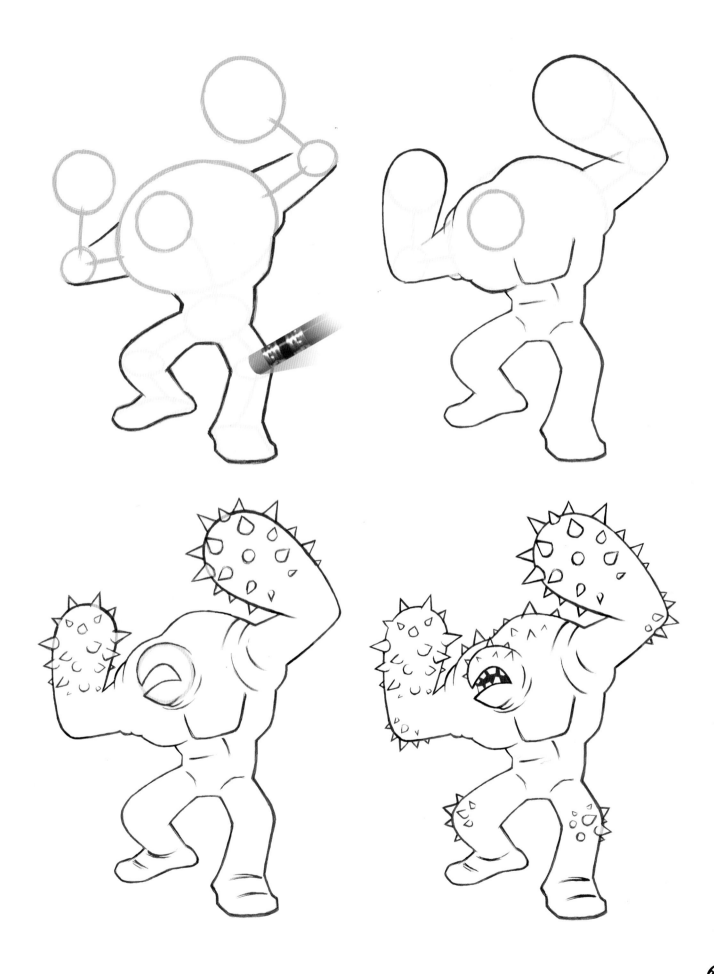

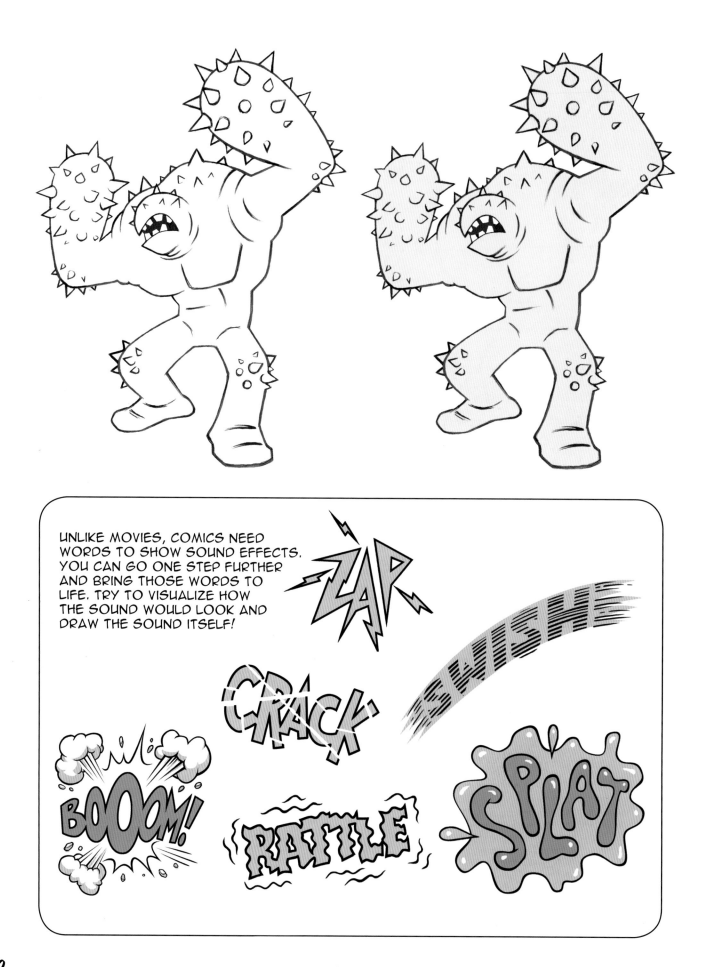

UNLIKE MOVIES, COMICS NEED WORDS TO SHOW SOUND EFFECTS. YOU CAN GO ONE STEP FURTHER AND BRING THOSE WORDS TO LIFE. TRY TO VISUALIZE HOW THE SOUND WOULD LOOK AND DRAW THE SOUND ITSELF!

ZAP

SWISH

CRACK

BOOOM!

RATTLE

SPLAT

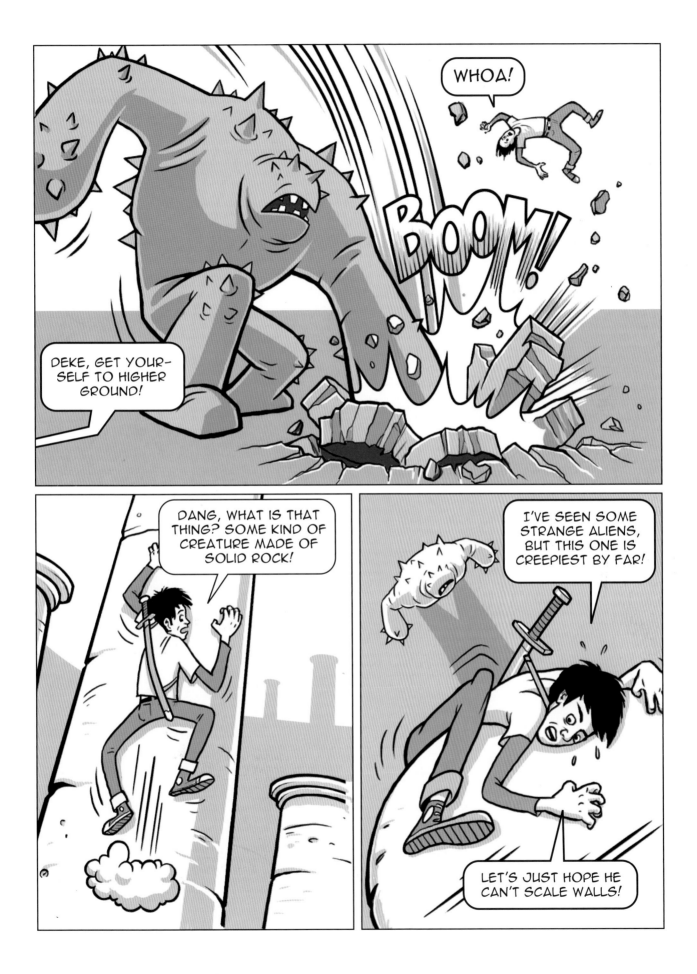

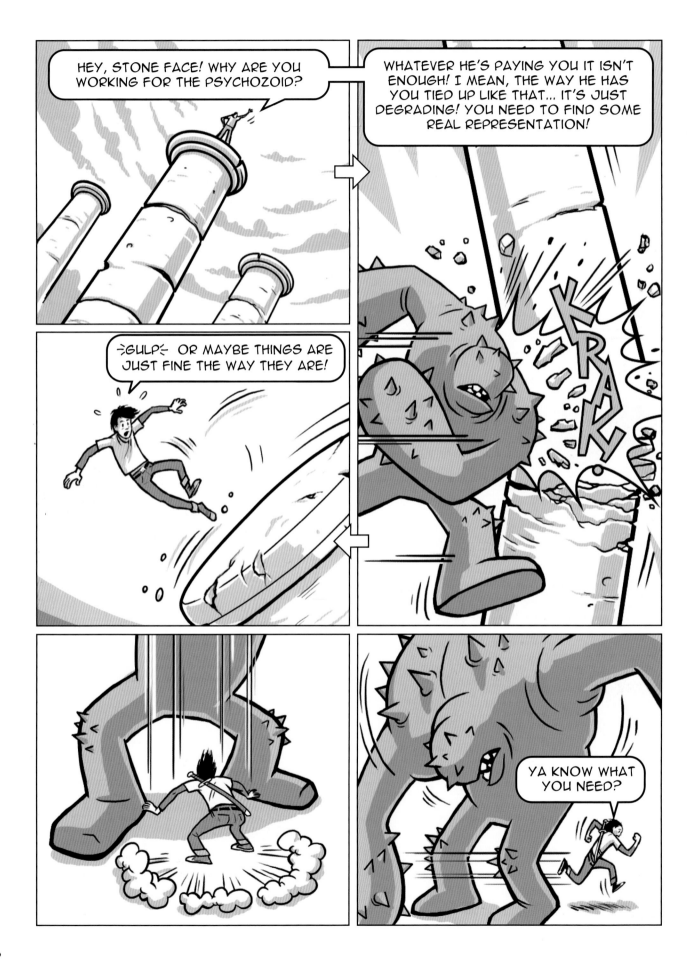

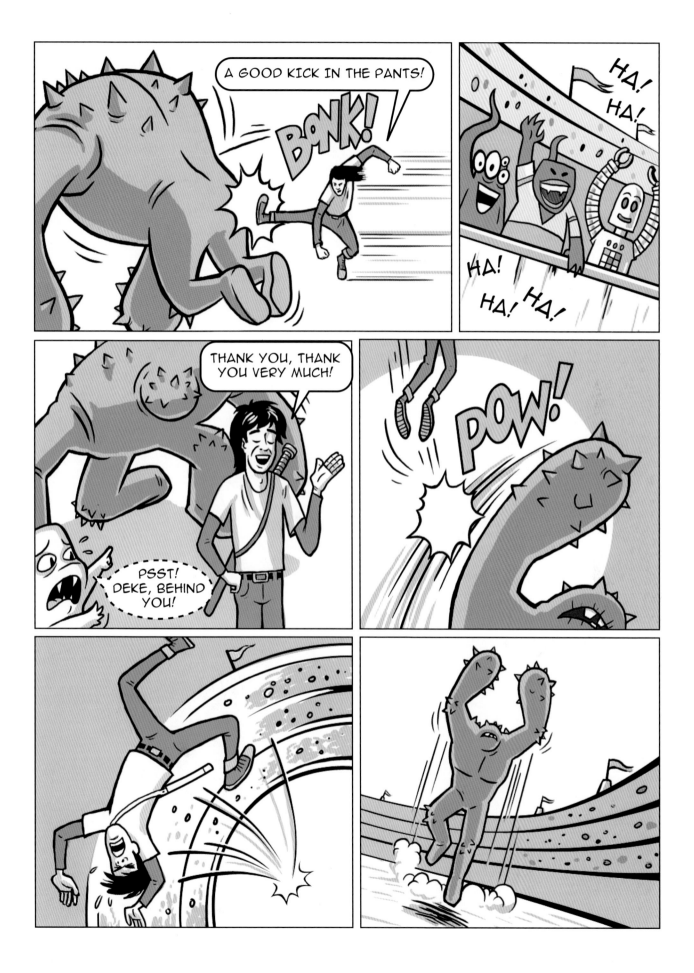

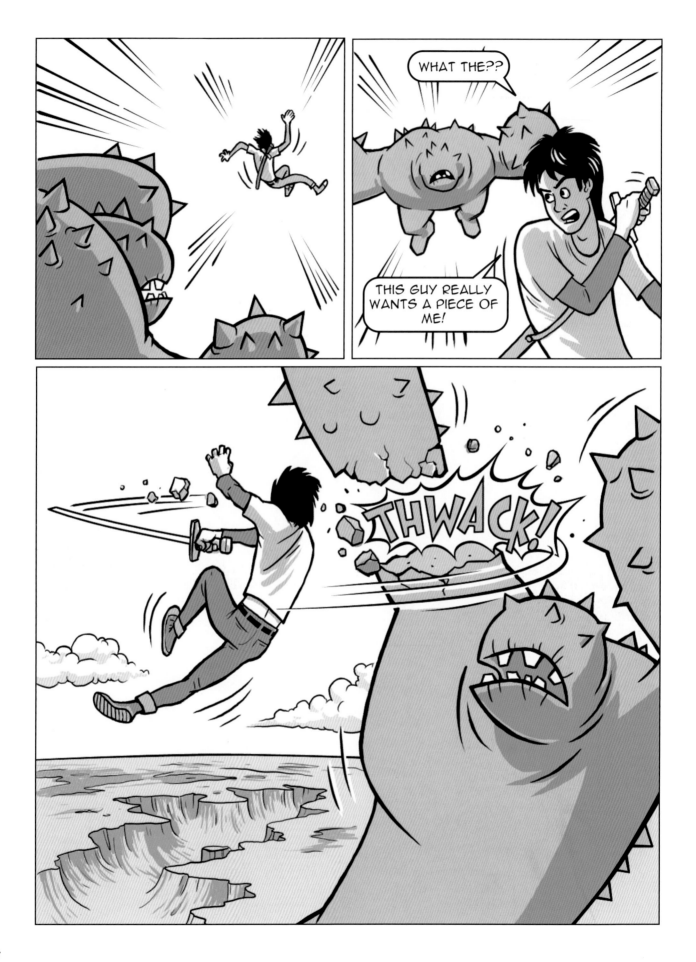

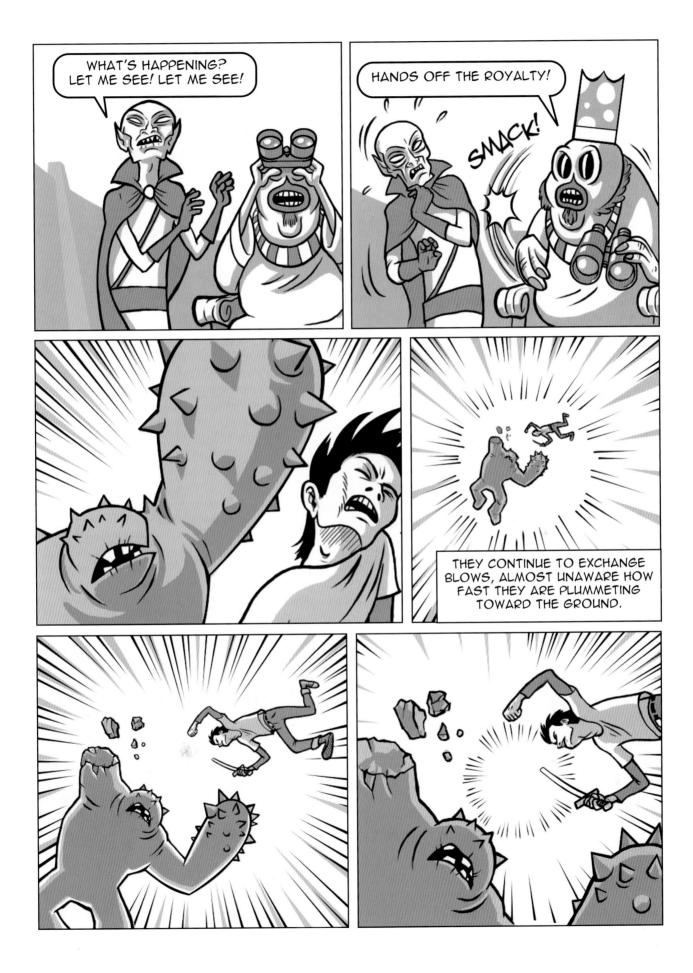

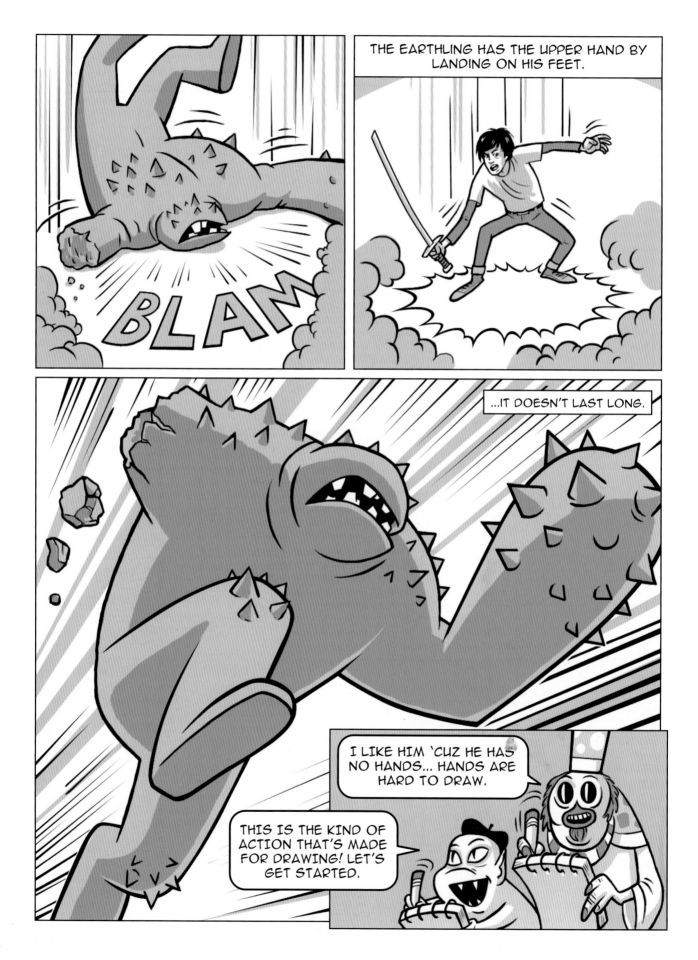

THE EARTHLING HAS THE UPPER HAND BY LANDING ON HIS FEET.

...IT DOESN'T LAST LONG.

I LIKE HIM 'CUZ HE HAS NO HANDS... HANDS ARE HARD TO DRAW.

THIS IS THE KIND OF ACTION THAT'S MADE FOR DRAWING! LET'S GET STARTED.

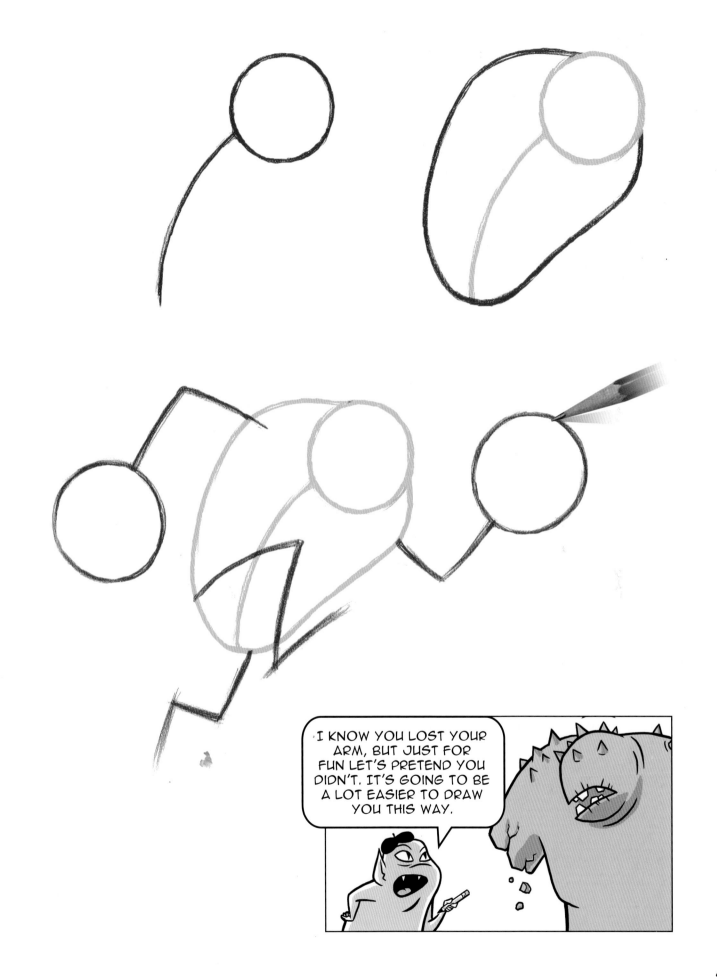

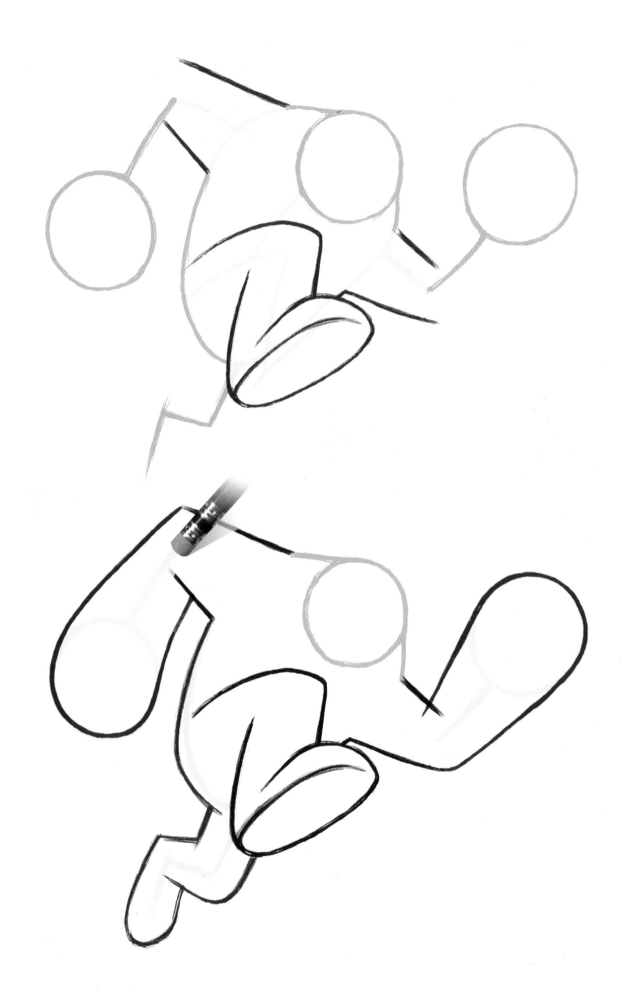

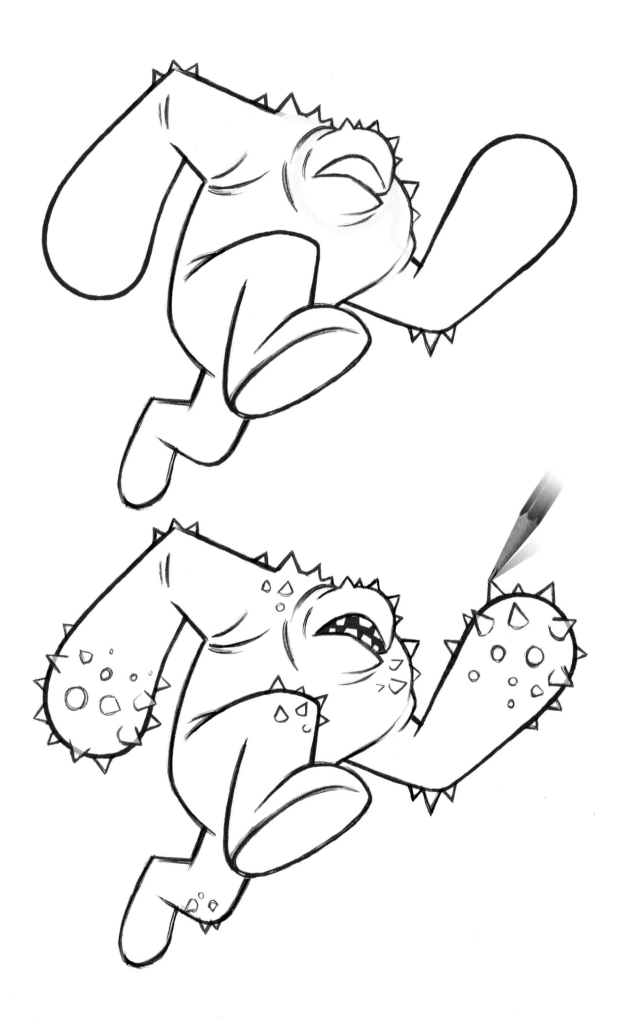

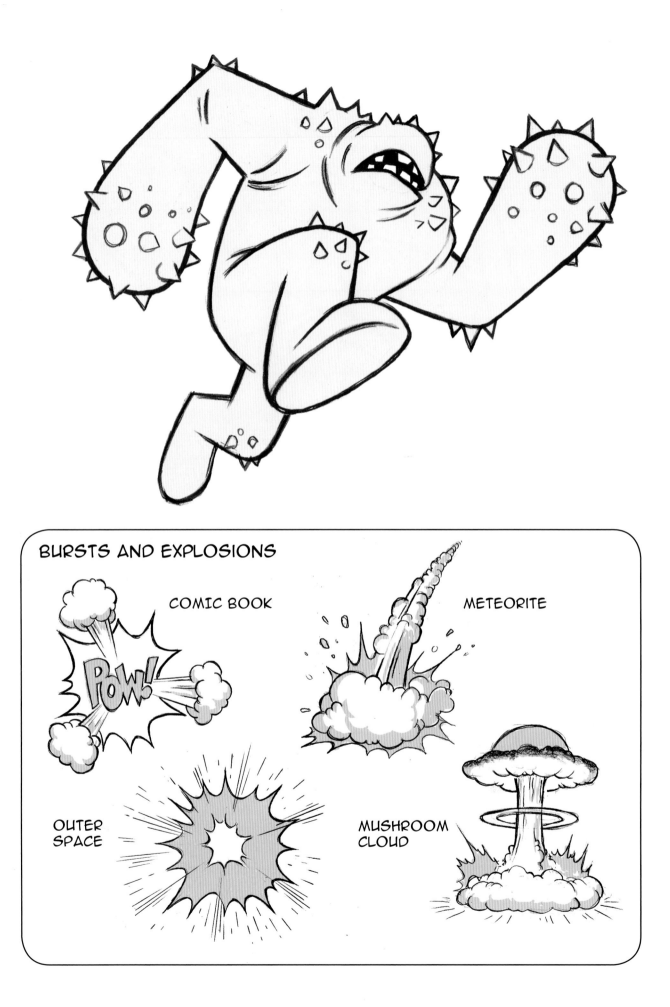

BURSTS AND EXPLOSIONS

COMIC BOOK

METEORITE

OUTER SPACE

MUSHROOM CLOUD

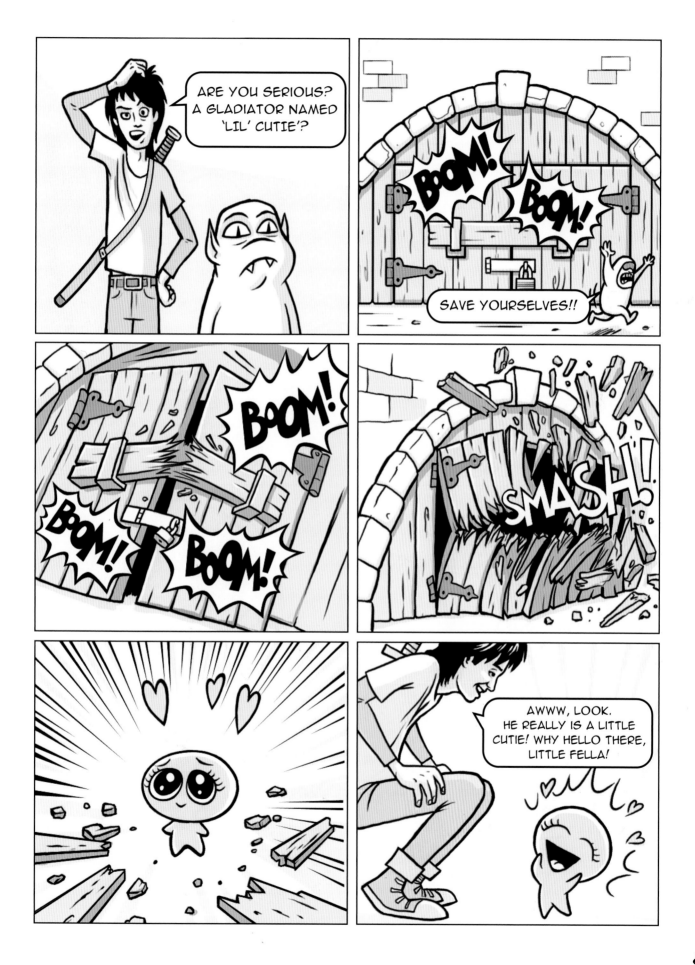

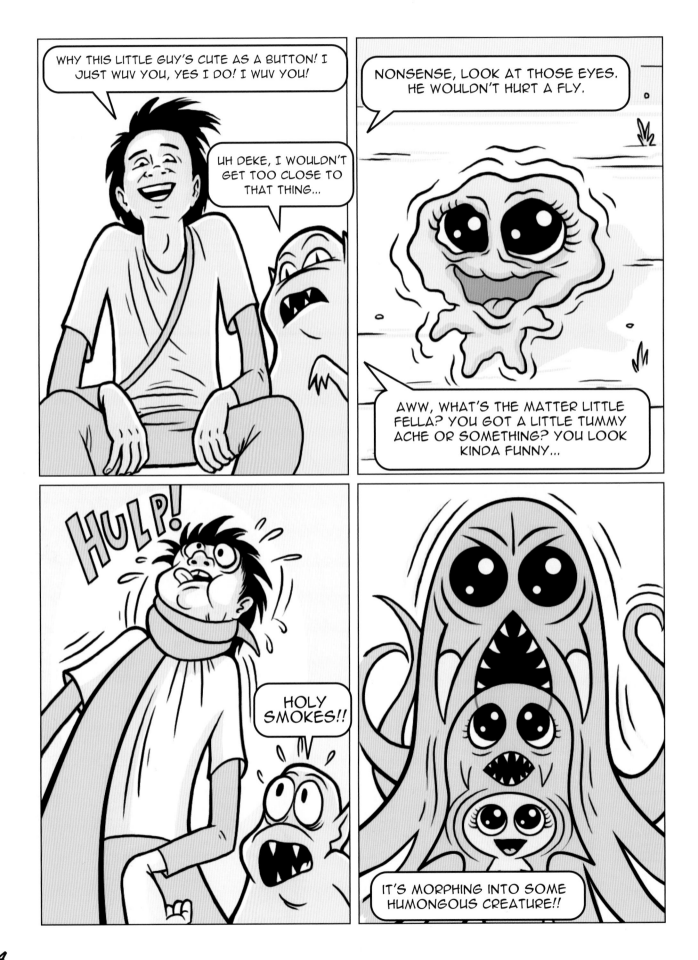

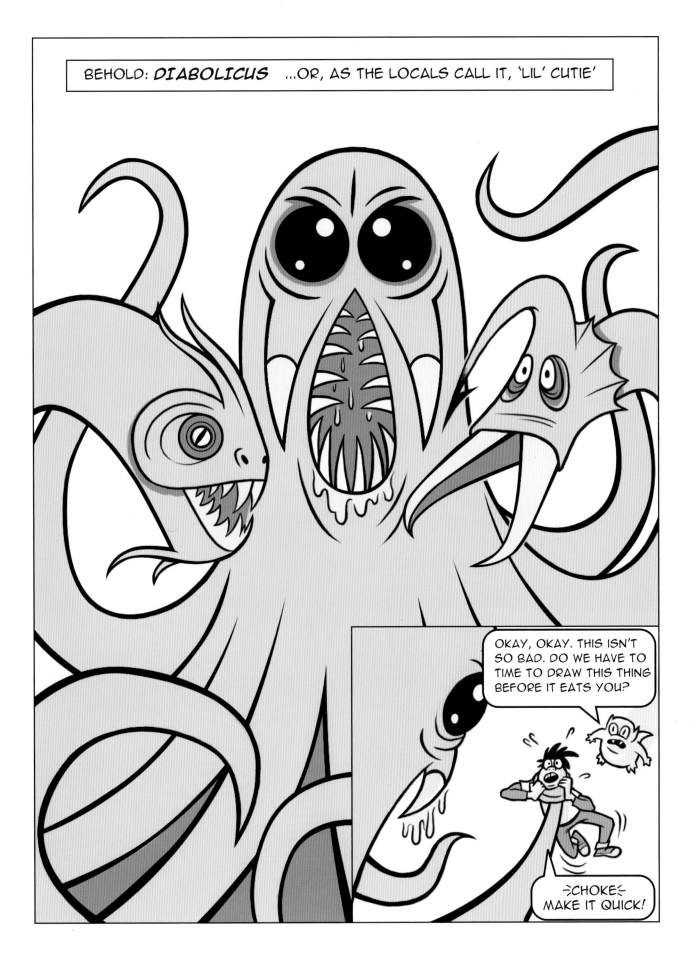

Diabolicus
(or Lil' Cutie)

NO ONE IS SURE OF ITS ORIGINS, BUT IF THERE IS A PLACE CALLED HELL, DIABOLICUS LIVES THERE. THIS NIGHTMARE DRAWS ITS VICTIMS CLOSE BY PRETENDING TO BE AN ADORABLE LITTLE CUTIE PIE. ONCE IN RANGE, THE CREATURE REVEALS ITS DEADLINESS. EACH OF ITS THREE HEADS MUST BE SEVERED BEFORE THE BEAST WILL DIE. (AND YOU WILL NEVER LOOK AT A BABY KITTEN THE SAME WAY AGAIN!)

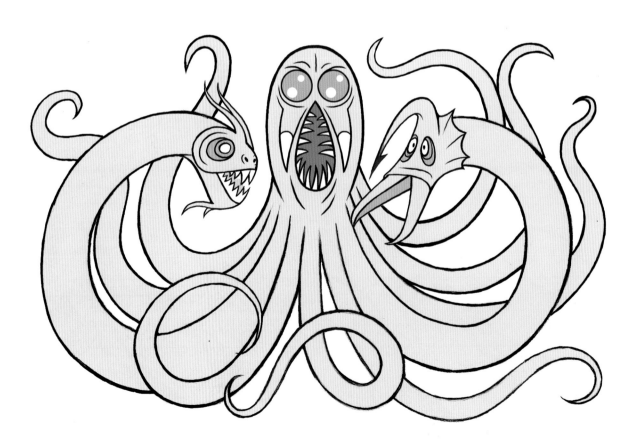

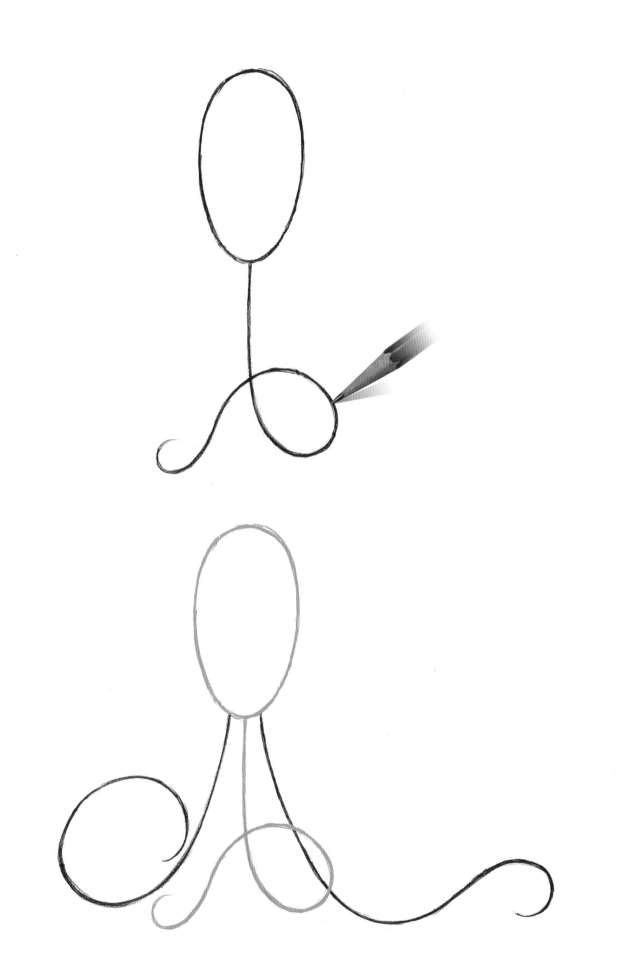

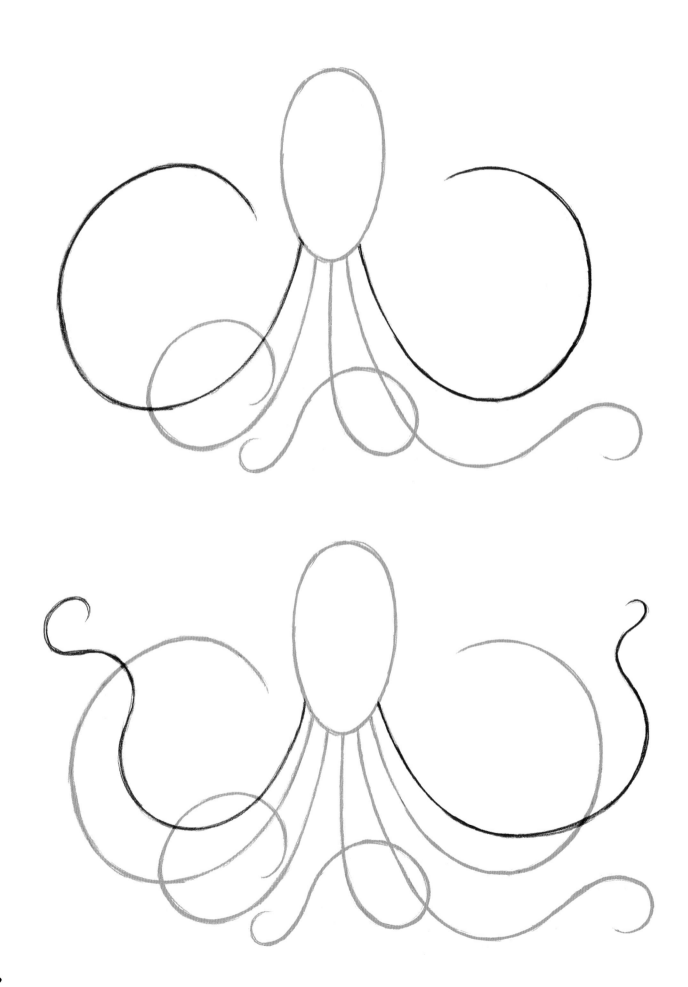

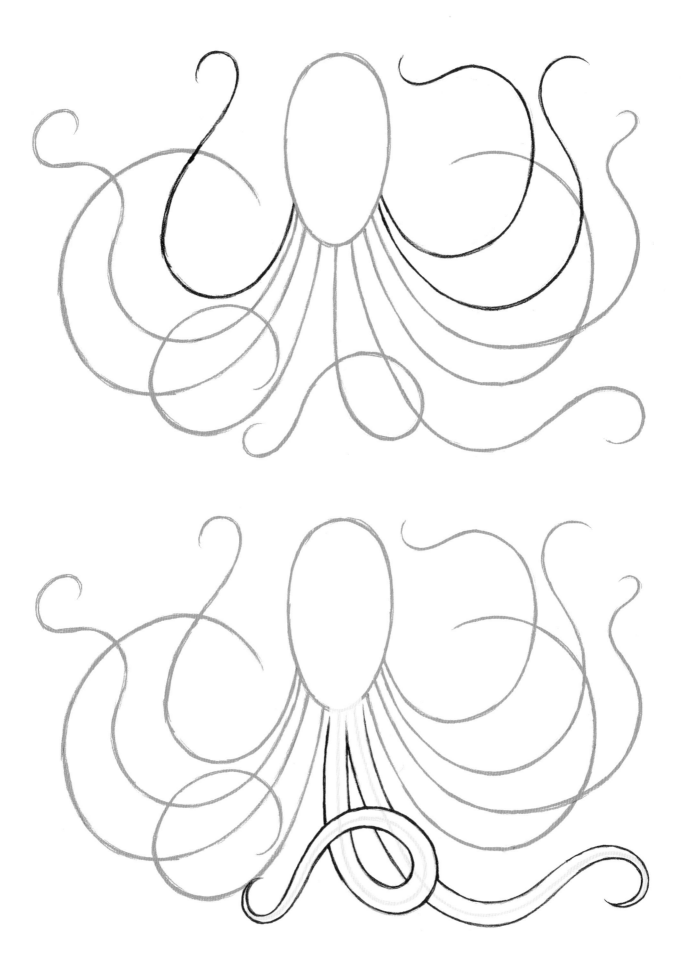

89

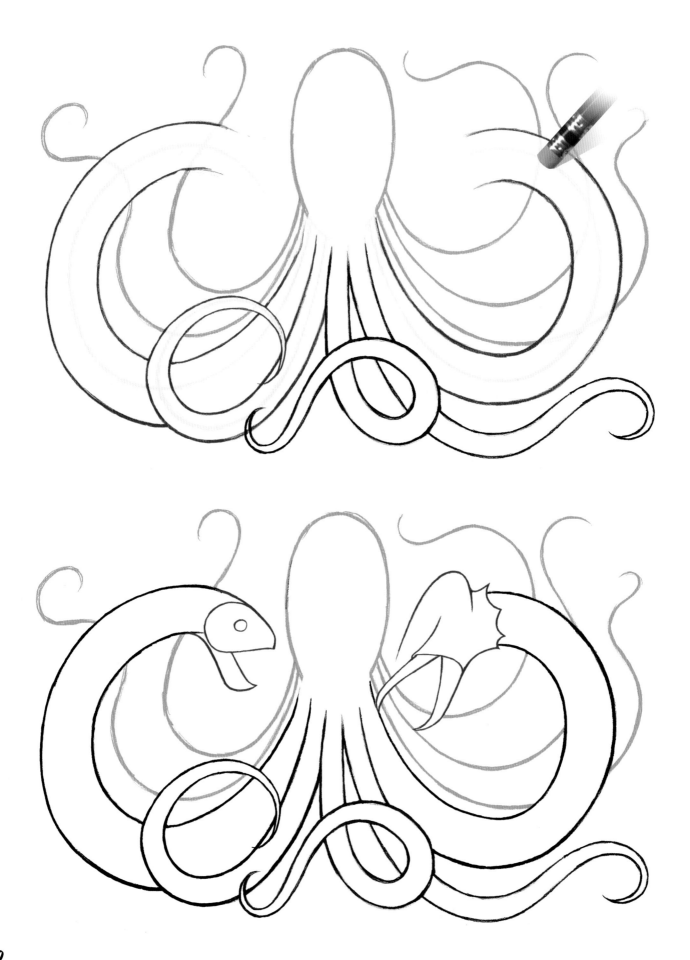

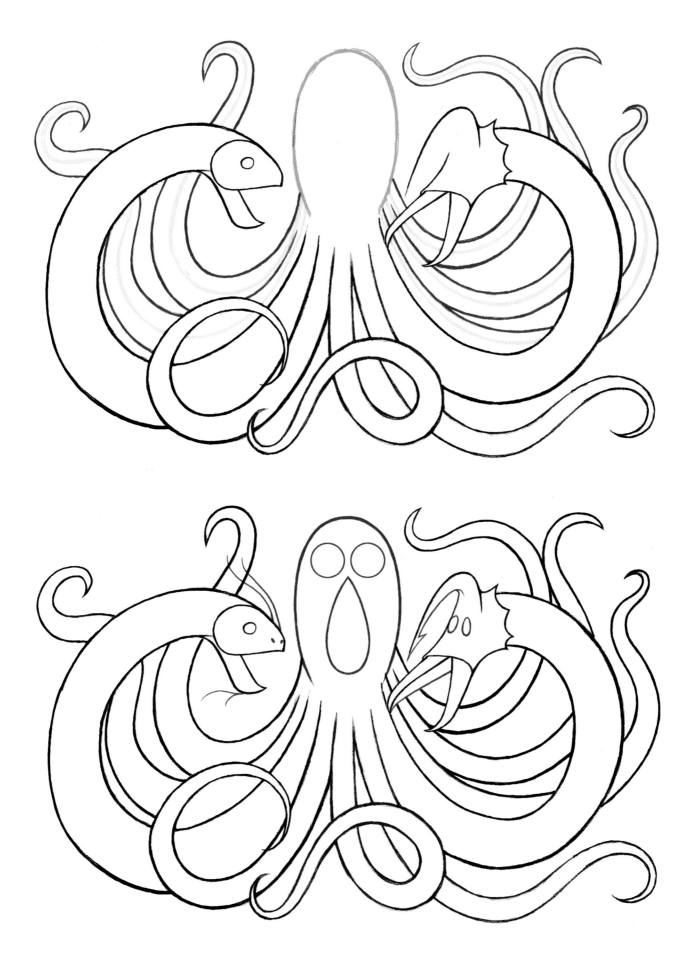

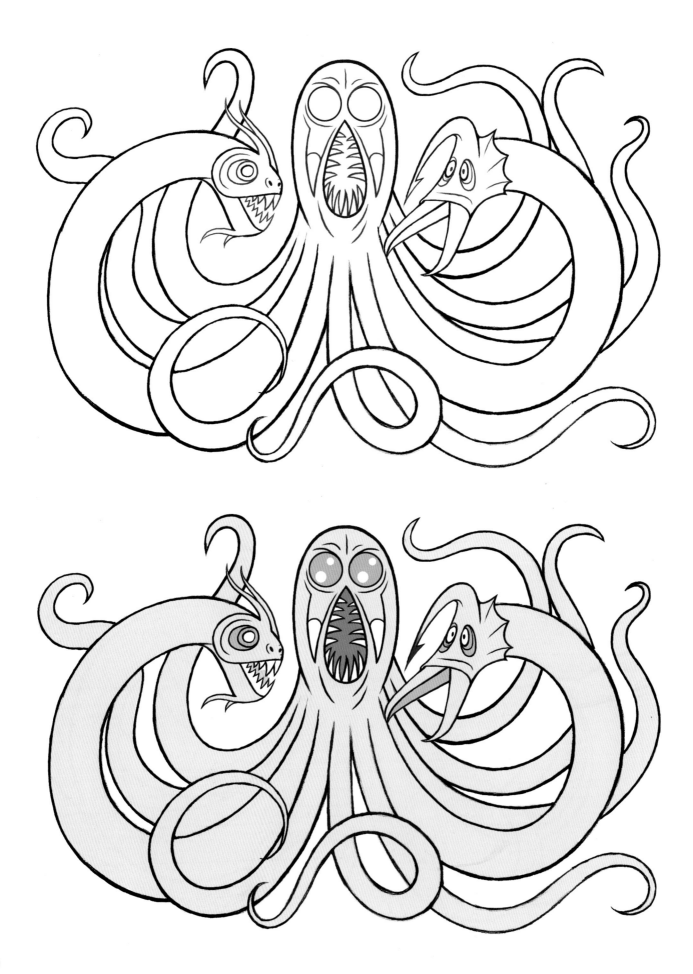

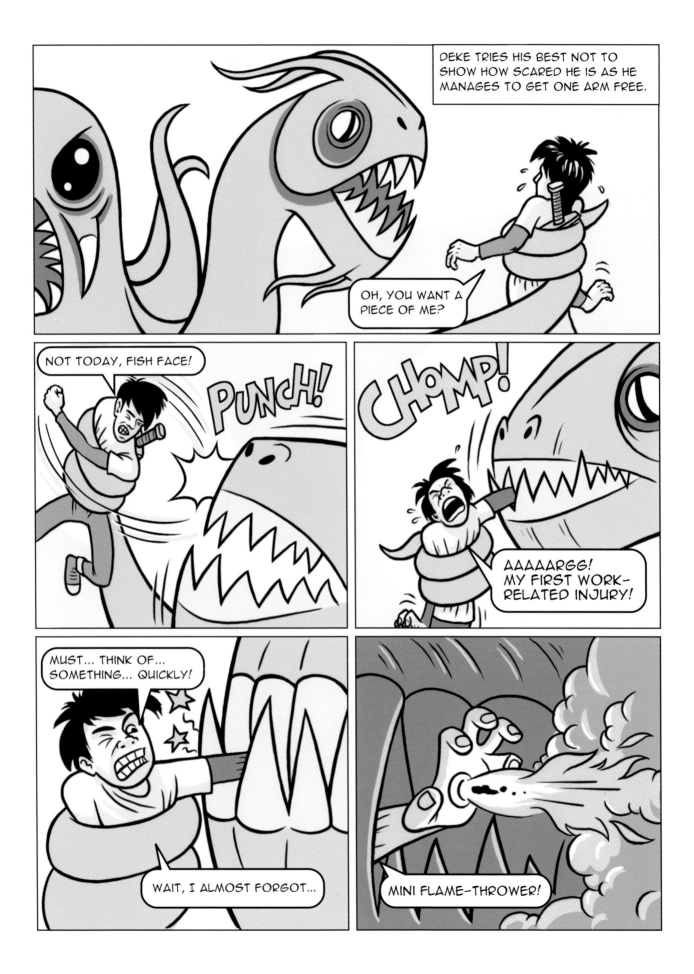

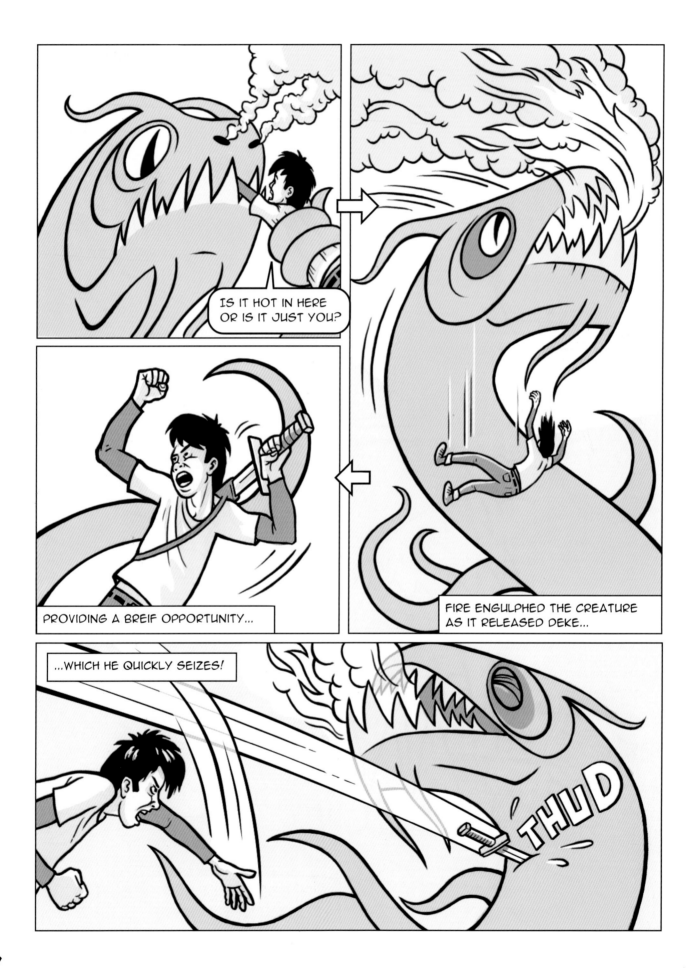

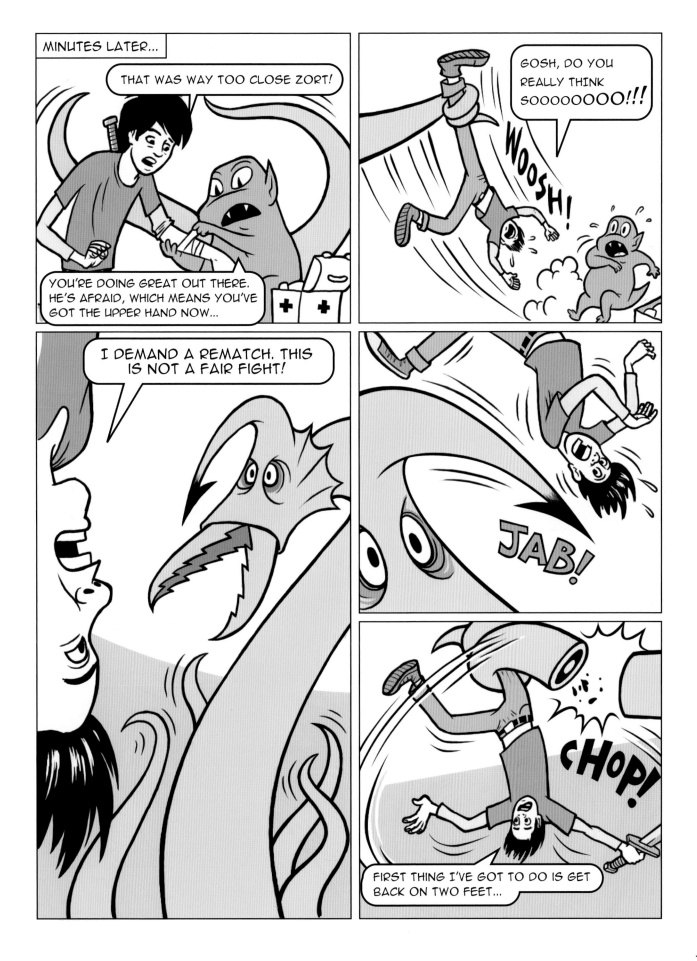

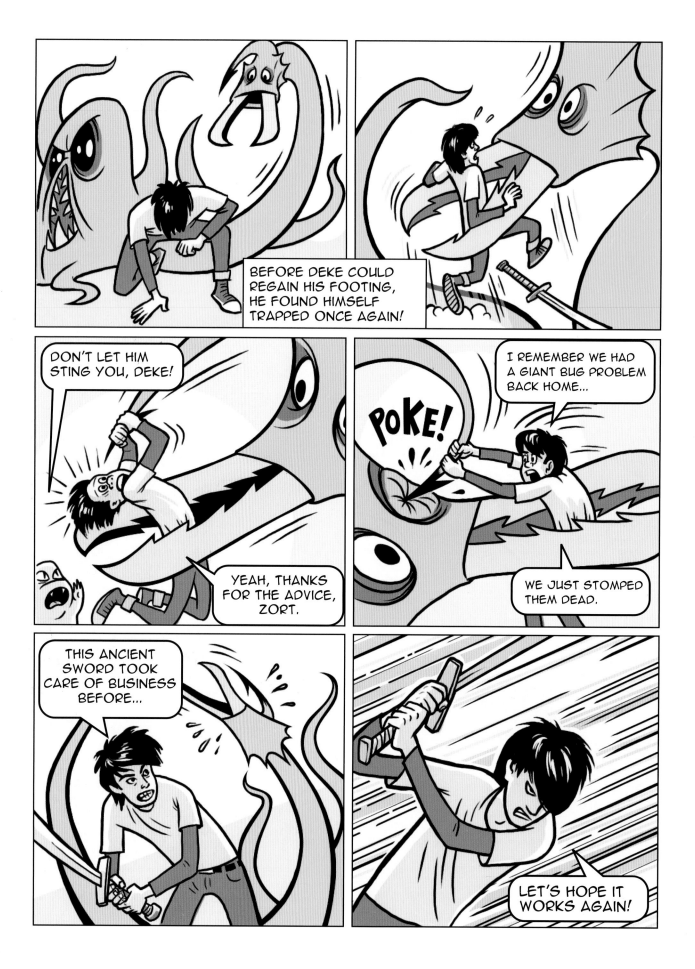

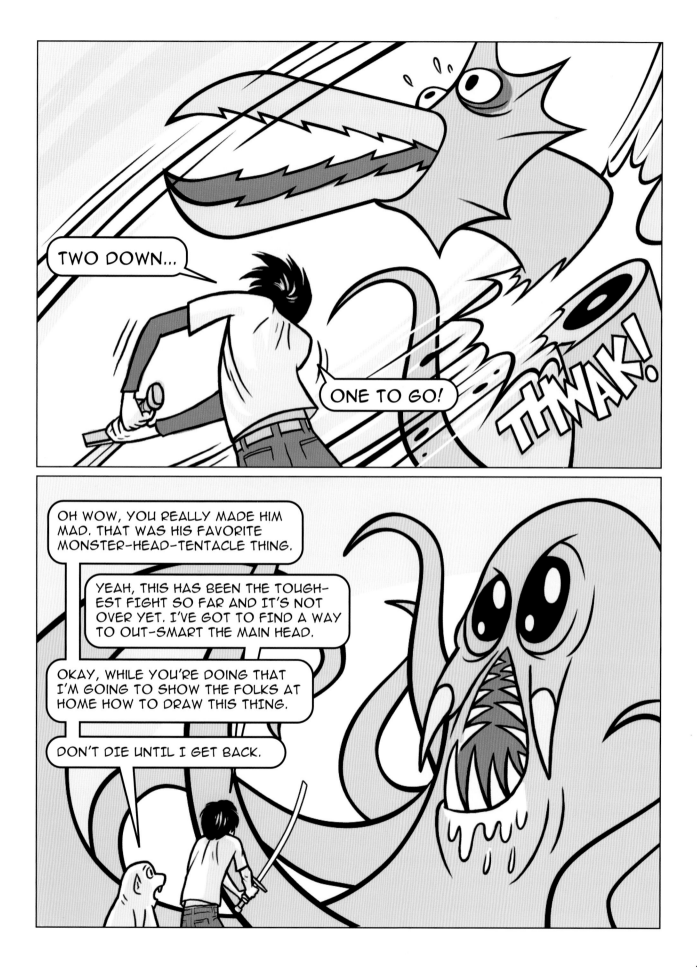

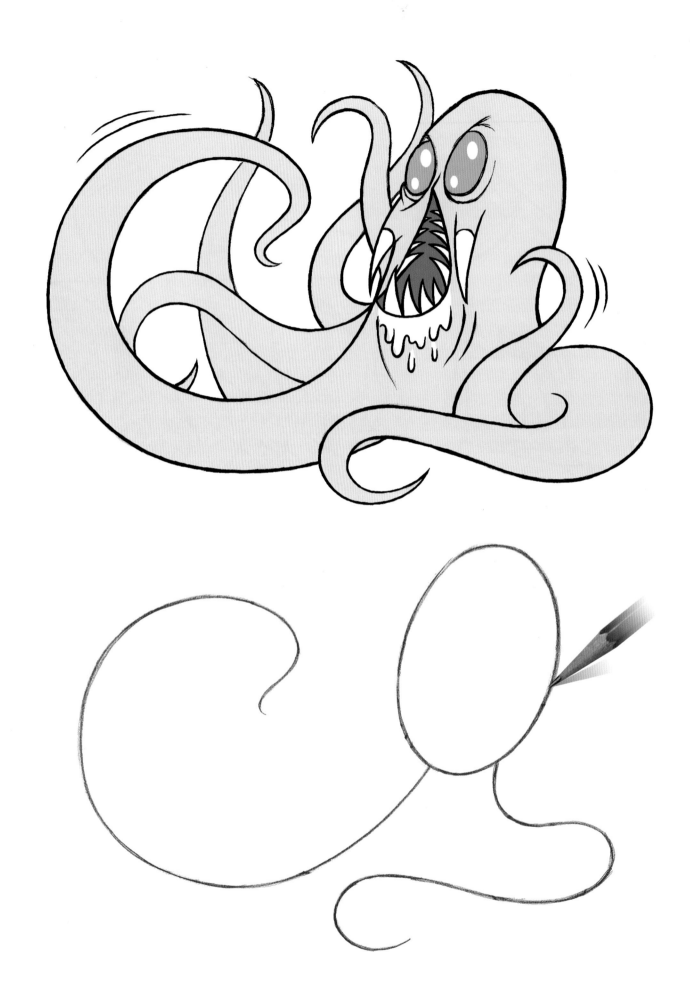

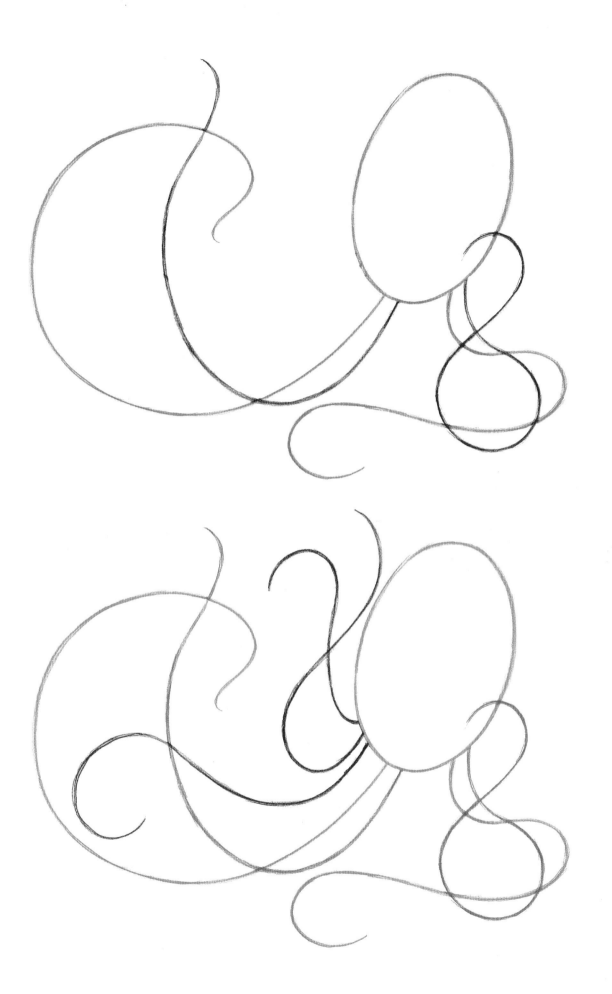

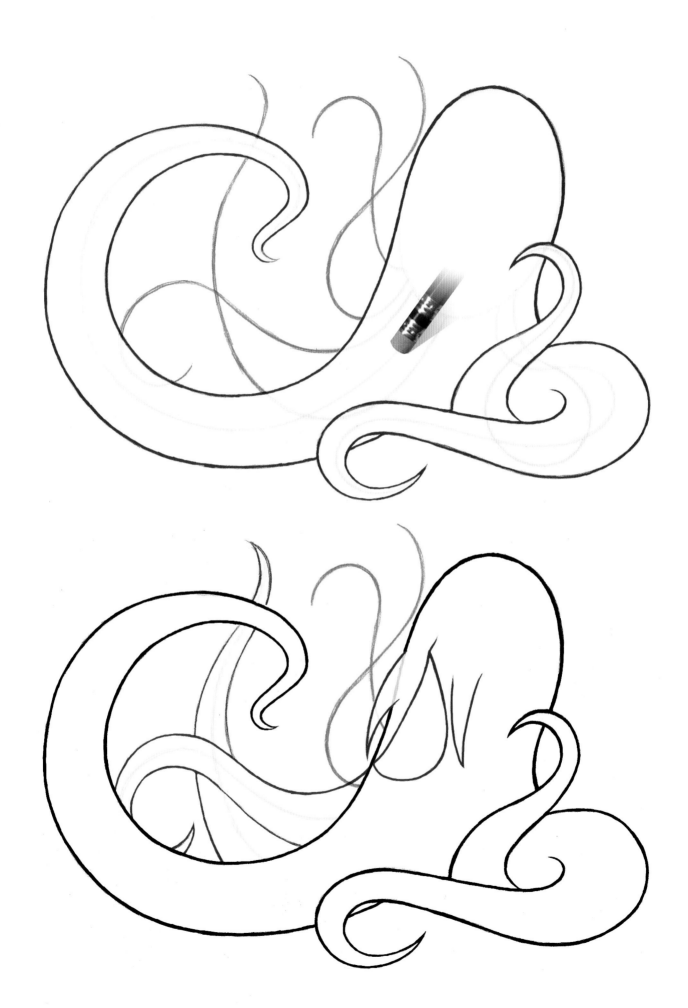

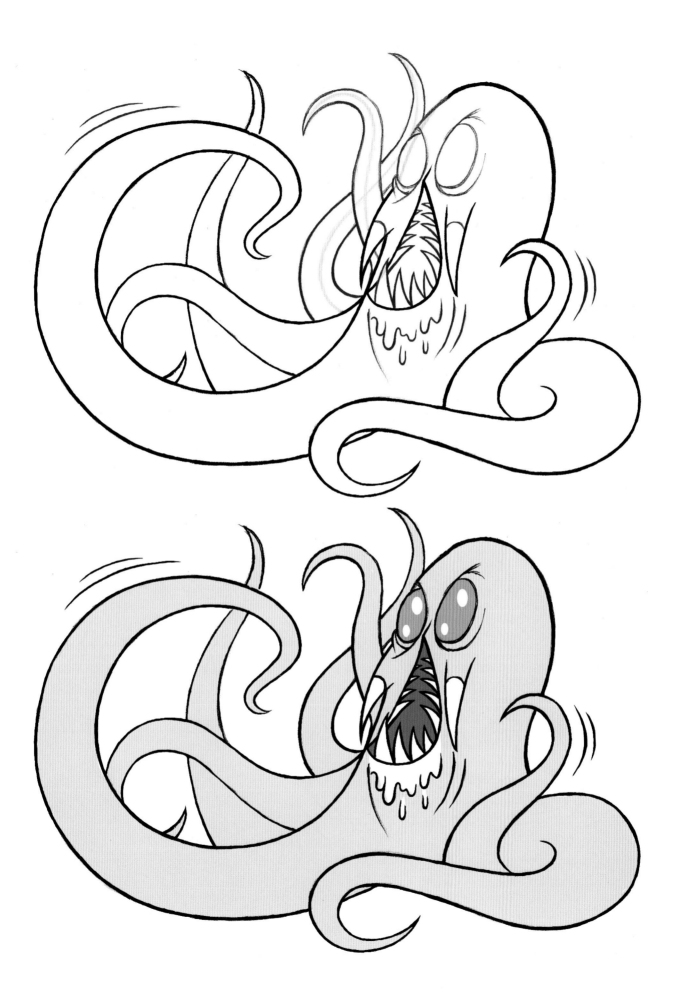

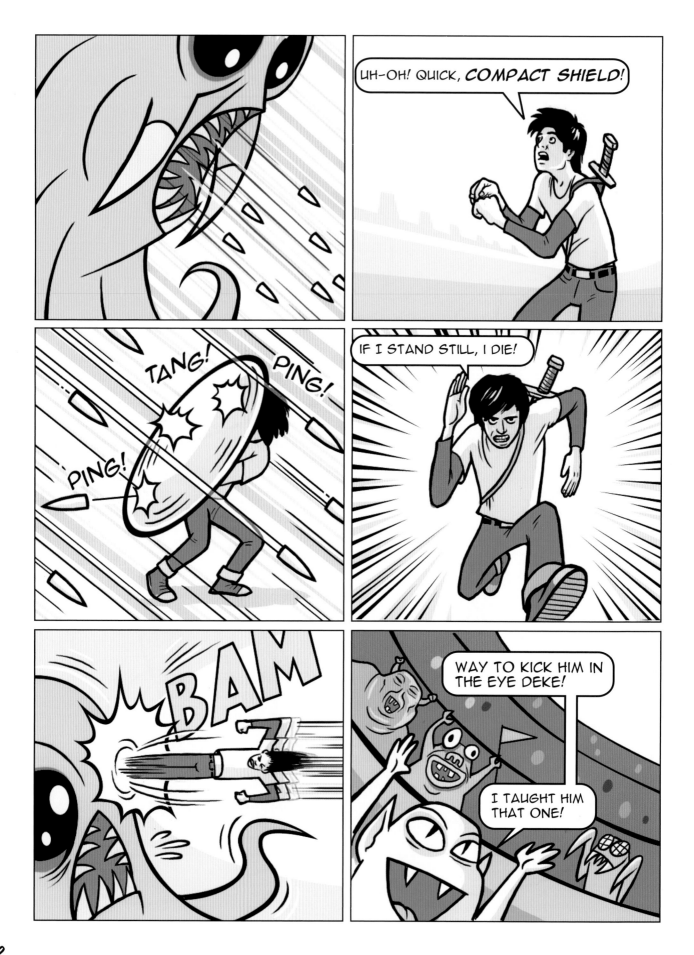

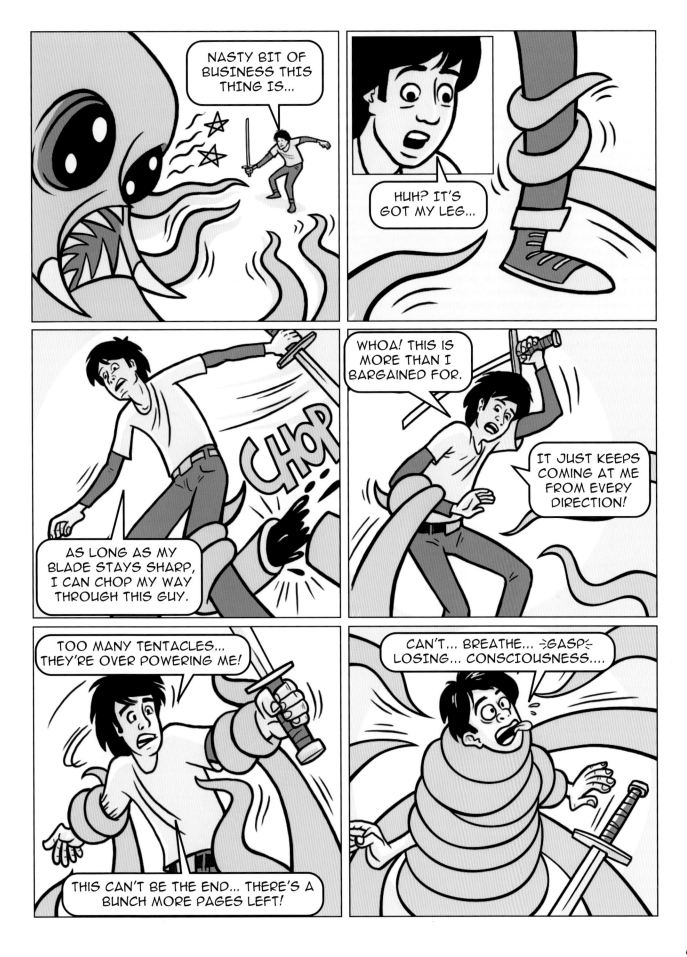

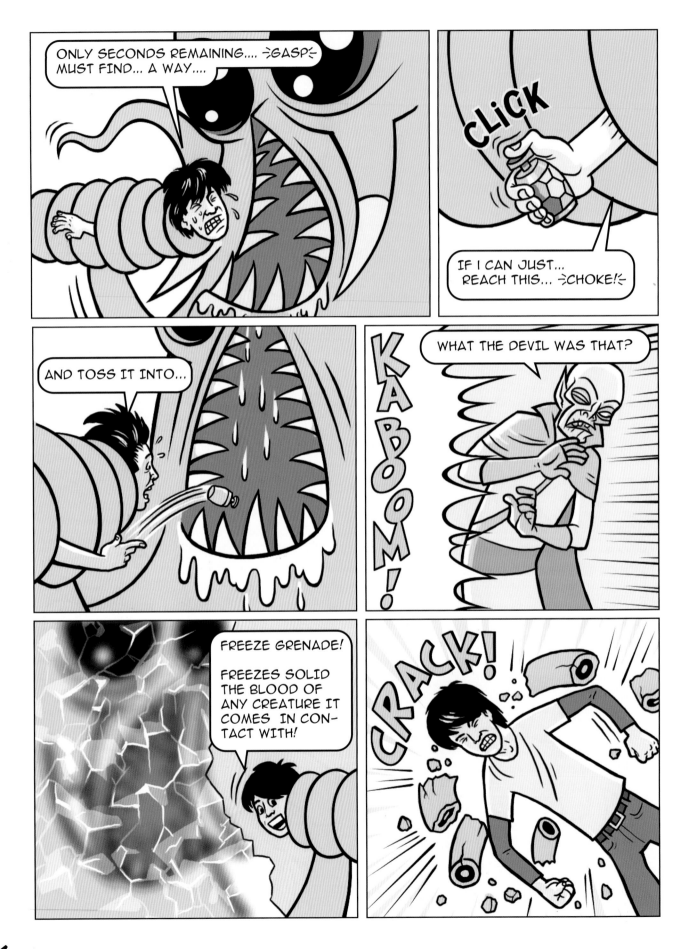

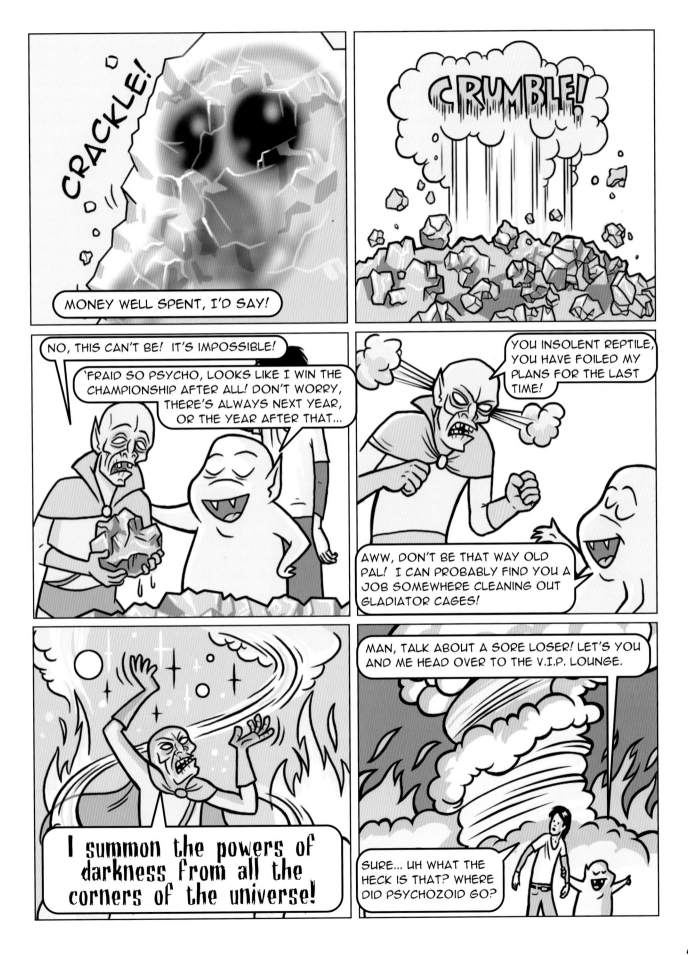

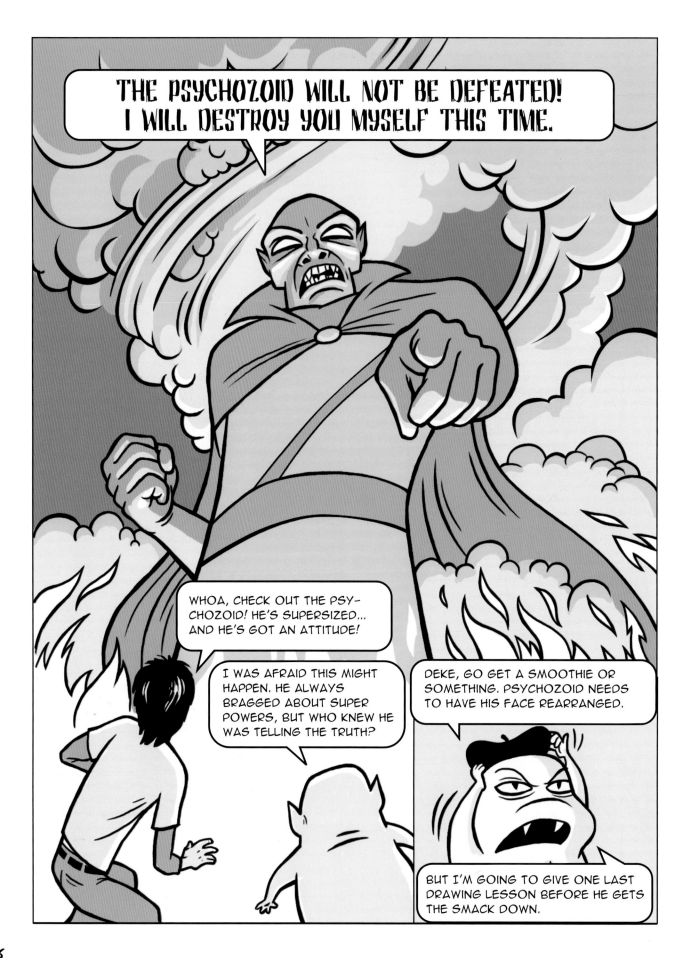


106

The Psychozoid

HE WASN'T ALWAYS ZORT'S NEMESIS. AS A YOUNG MAN PSYCHOZOID WAS AN EXCEPTIONAL STUDENT WITH DREAMS OF USING HIS SUPER INTELLIGENCE TO MAKE THE UNIVERSE A BETTER PLACE. HOWEVER, HE WAS A NERD AND, AS SUCH, HE WAS SUBJECT TO RIDICULE BY PRETTY GIRLS AND REGULAR BEATINGS BY THE JOCKS. HIS ANGER TURNED TO RAGE AS HE VOWED REVENGE ON ALL LIVING THINGS. APART FROM BEING AN EVIL GENIUS, PSYCHOZOID POSSESSES BASIC WIZARDRY SKILLS SUCH AS LEVITATION, HYPNOSIS, AND THE ABILITY TO SHOOT ENERGY. AS YOU CAN SEE HERE, HE CAN ALSO CHANGE HIS SIZE DRAMATICALLY.

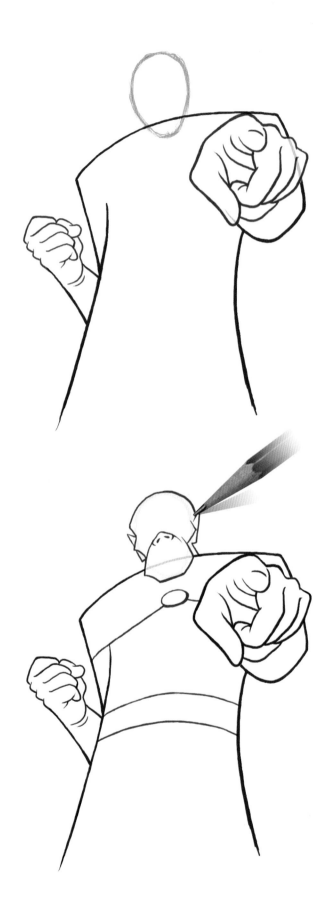

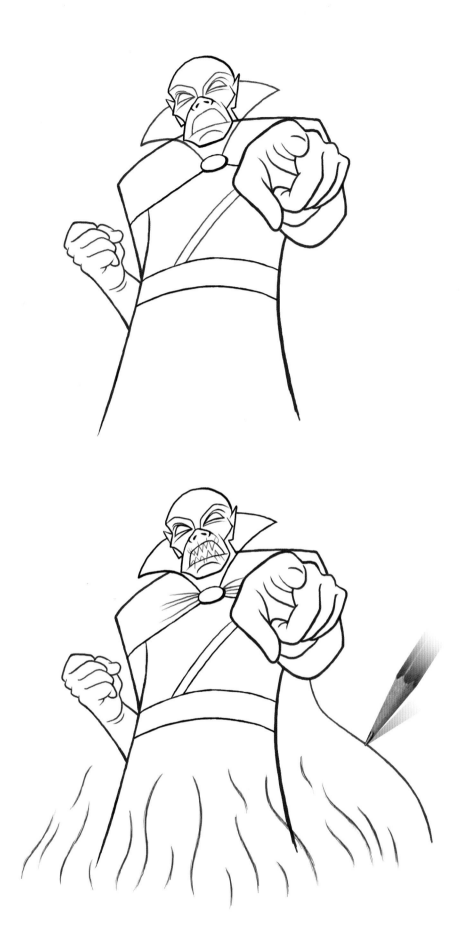

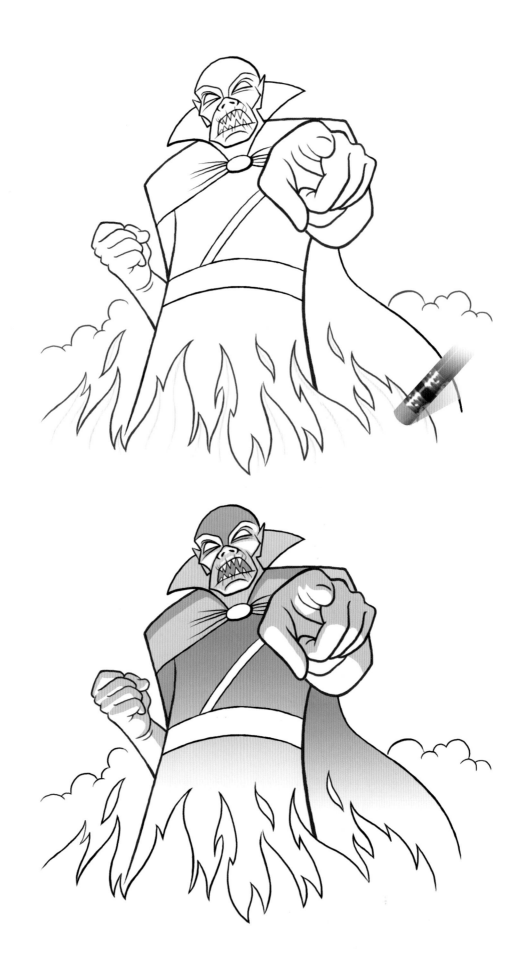

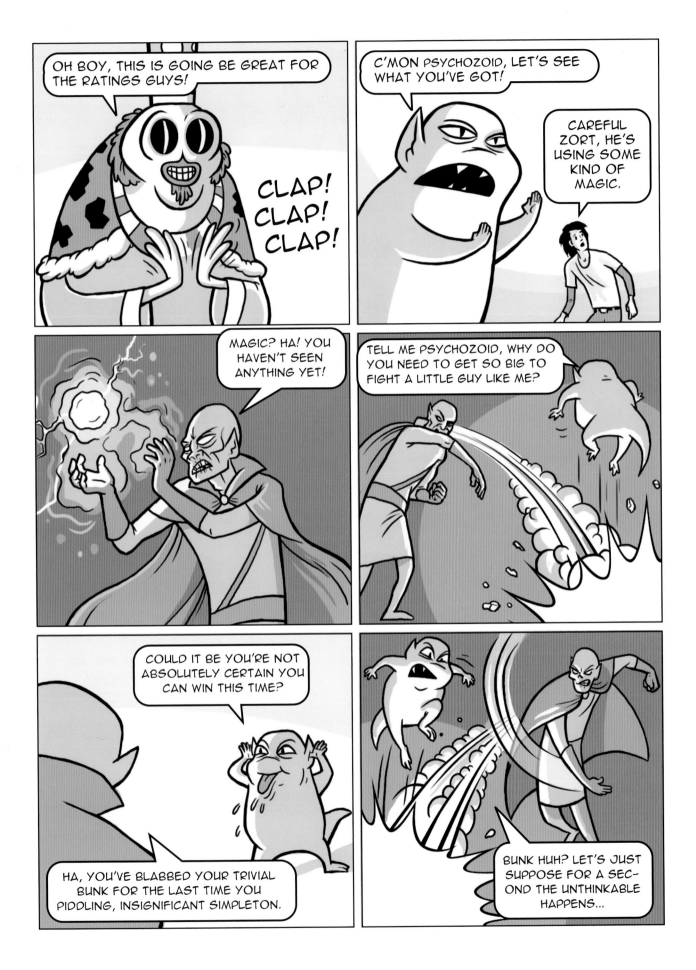

112

THE END... SEE YOU NEXT SEASON!

HERE ARE SOME BONUS CHARACTER DESIGN SUGGESTIONS!

HEADS

The most important part about creating an alien creature is the face. It says everything about the personality. The eyes, nose, ears, and mouth can be anyplace or nowhere at all. Below are a few examples of very different creatures created with the same basic shapes.

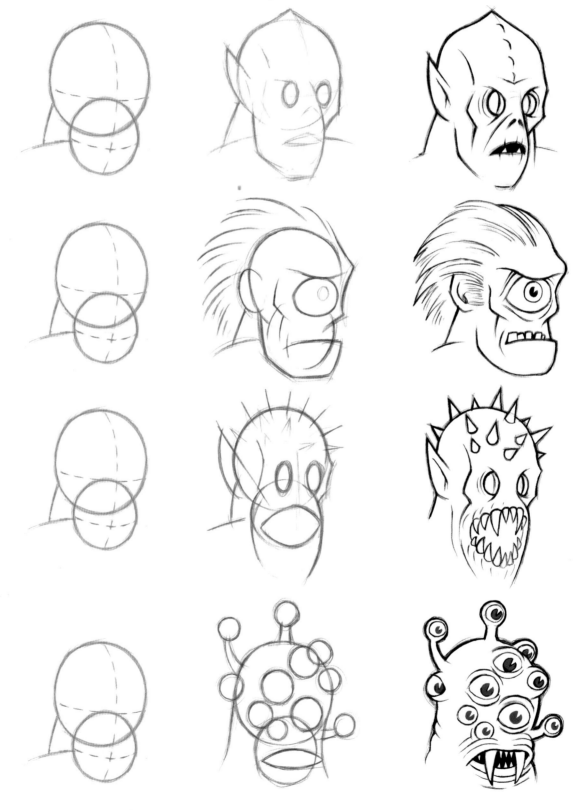

EYES

If you're going to draw eyes at all, the placement and size is important. Big bug eyes are good for brainy time travelers, whereas deep-set, hooded eyes depict more strength and dominance. Generally, most alien eyes are drawn without pupils. This makes the creature look more mysterious. Drawing the two eyes different sizes creates a more deformed or mutated alien.

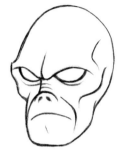

Deep-set, hooded eyes create a sinister, mysterious look. Instead of pupils, try a solid color or glow.

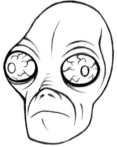

For crazier or insane look, try pushing the eyes outward, popping out of the head. Use veins to exaggerate.

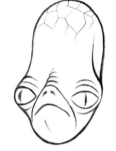

Lowering the eyes to nose level makes your creature more amphibious, or frog-like. Try using vertical reptile pupils.

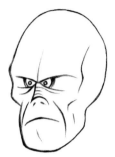

Placing very small eyes close together make for a dumb, or easily frustrated character.

NOSES

Most artists ignore the nose when designing aliens, or they make it very small. Be different—add a prominent snout on your beast.

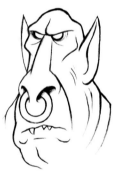

Big creatures are more likely to have a big nose. Add some nose jewelry to give him the look of an ancient race.

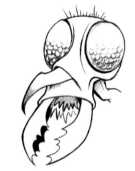

Insect aliens can have noses too. It's a good place to have a deadly stinger.

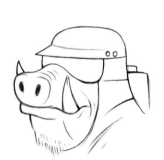

Don't be afraid to use animal noses on your aliens. This guy has the snout of a wild boar.

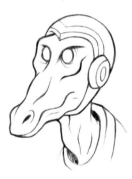

The head of a dino-reptilian character is almost all nose.

TEETH

I think you'll agree when I say nothing makes a character more threatening than a mouthful of razor-sharp teeth. Fangs and such can be a little tricky at first. It's helpful to examine the skull of an actual predator, such as an alligator or tiger.

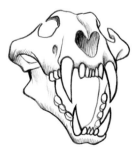

When drawing fangs, it helps to study the skull of an actual predator.

Crooked and chipped teeth with an under bite can look menacing.

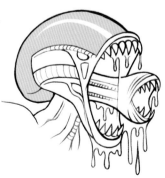

Popular Hollywood aliens sometimes have a mouth within a mouth.

ADD LOTS OF DRIPPING GOO TO MAKE YOUR ALIEN LOOK MORE REPULSIVE!

HANDS

Not all aliens have hands. But if you want to create them, here are some helpful hints: Smarter, less physically threatening creatures have long, skinny hands, which are more useful for operating computers and laser guns than for hand-to-hand combat. Two or three fingers are all he needs.

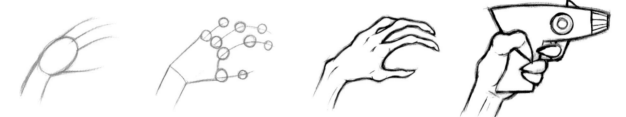

The giant hands of an alien warrior usually need good, sharp claws to help grab their victims. Sometimes they wear battle gear such as spiked leather wrist bands. The fingers are short and thick.

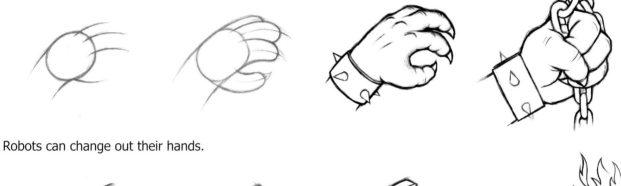

Robots can change out their hands.

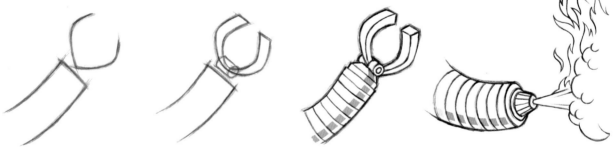

FEET

The feet are just as powerful as hands, but they're more vulnerable. Make sure you add some defensive armor.

Most do not wear shoes, but if they do, it's usually some kind of armored space boot with concealed weaponry or rocket boosters.

In the wastelands of distant planets, aliens need good, strong feet. Warriors need large claws for fighting. Many times, dinosaur feet work well.

Planets covered with slime and goo are where you can find creatures with high-traction spikes. Leave the ends open if you want them to shoot poison rockets.

If a droid loses a leg, it can easily be defeated. They need special armor to stay mobile. If wheels are used, they need to be concealed.

SETTING UP YOUR SCENE

When setting up your scene in a drawing or comic, you're doing the same job as any famous movie director. It's important that your audience sees exactly what you want them to see, in the best way possible. Try to imagine that you are viewing the comic book panel through the lens of a camera. You can tilt, zoom, pan... actually you can do much more than any camera can! The position of the camera has a huge impact on the feeling of the scene. Just watch any action movie on T.V. and notice how they change the camera angle to alter the mood of the story. The illustration below shows how one scene can have a completely different feel just by changing camera angles.

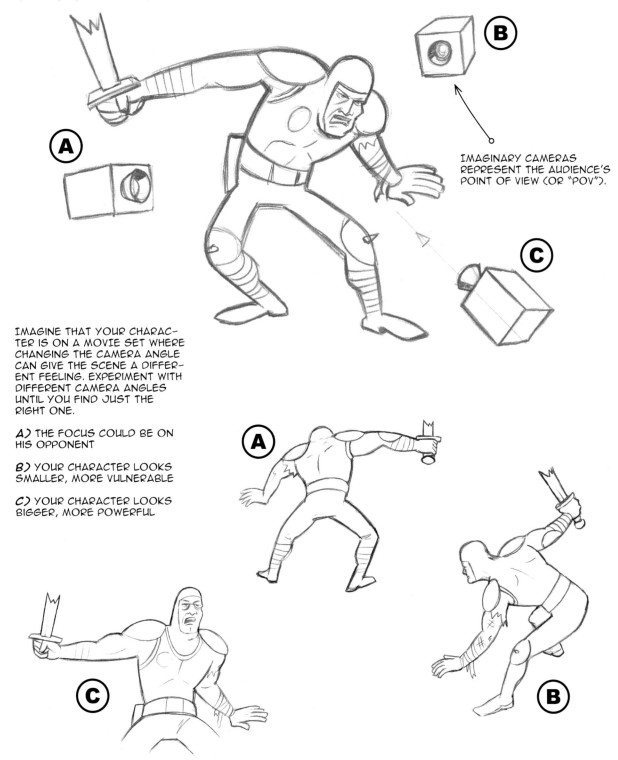

IMAGINARY CAMERAS REPRESENT THE AUDIENCE'S POINT OF VIEW (OR "POV").

IMAGINE THAT YOUR CHARAC-TER IS ON A MOVIE SET WHERE CHANGING THE CAMERA ANGLE CAN GIVE THE SCENE A DIFFER-ENT FEELING. EXPERIMENT WITH DIFFERENT CAMERA ANGLES UNTIL YOU FIND JUST THE RIGHT ONE.

A) THE FOCUS COULD BE ON HIS OPPONENT

B) YOUR CHARACTER LOOKS SMALLER, MORE VULNERABLE

C) YOUR CHARACTER LOOKS BIGGER, MORE POWERFUL

ABOUT THE AUTHOR

During daylight hours, **Dana Muise** is an animator working in the broadcast and T.V. cartoon industry. By night he lives in the world of comics, monsters, and space creatures. When other kids were learning how to draw happy trees and rainbows, he was perfecting his army of giant claw creatures as they prepared to battle the menacing space bugs on Planet Zoltor. The only thing he likes better than space monsters is teaching people how to draw them. As far as he knows, space monsters are real and we should know how to draw them before they get here. Dana attended Massachusetts College of Art in Boston and the School of Visual Arts in New York. He lives in beautiful San Francisco, California, with his talented artist wife Leigh and daughter Eva, who is his favorite little monster of all. Below are some of the many drawings he made as a kid. Dana notes, "I especially thank my dad for holding onto these as I grew up!"

Monster On The Loose! Dana Muise: Age 7

Space Trooper Under Attack Dana Muise: Age 8

War on the Planet Xelton Dana Muise: Age 9

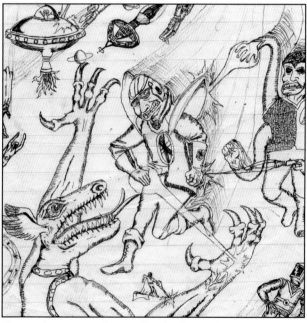

Super Awesome Space Battle Dana Muise: Age 10